# RENOVATIO CHRISTIANA

THE COUNTER REFORMED PATRONAGE OF
POPE SIXTUS V AT THE HOLY STEPS IN ROME
(1585–1590)

BY

STEFANO SANDANO

ISBN: 1492992372
ISBN 13: 9781492992370

Library of Congress Control Number: 2013918897
CreateSpace Independent Publishing Platform
North Charleston, South Carolina

# CONTENTS

# LIST OF ABBREVIATIONS

BSBV—*Bullarum Sacrosanctae Basilicae Vaticanae* (21 Vol. Edition Maria Salvioni Typographus Pontificius Vaticanus, 1747). It contains the papal bulls from Leo X Medici to Clemens XII).

LP—*Liber Pontificalis*. Duchesne L. and Cyrille Vogel, *Le Liber Pontificalis* (Paris: E. de Boccard, 1955). It is a primary source that lists the early martyrs of Rome and describes the popes' biographies from Saint Peter to the fifteenth-century pontiffs.

ASR—*Archivio di Stato Roma.*

MK—*Gospel of Mark*

MT—*Gospel of Matthew*

LK—*Gospel of Luke*

JN—*Gospel of John*

GN—*Book of Genesis*

EX—*Book of Exodus*

NUM—*Book of Numbers*

JUD—*Book of Judges*

KGS—*Book of Kings*

JA—*Book of Jonah*

# TERMINOLOGY

- ACHEROPOIETON: This Greek adjective literally means "not made by human hands "and refers to the supernatural qualification attributed to the image of Christ venerated inside the Sancta Sanctorum.

- AVVISO: These official documents were issued by the Apostolic Chamber, through which the pope acted as a governor of the city of Rome and discussed nonreligious matters. The majority of the *Avvisi* are preserved in the Vatican Library, but some of them were used as primary sources by Ludwig von Pastor's *History of the Popes* in the nineteenth century. These documents are a relevant, primary source for those studying papal urban interventions.

- CAPPELLA PONTIFICIA: This term does not define a building related to the papal ceremonies but comprises the pontifical household, including all the collaborators of the pope, such as deacons and masters of ceremonies.

- SCALA SANTA: New Renaissance term introduced by Sixtus V in his document *Cum Singularum Rerum* for the Holy Steps.

- SANCTA SANCTORUM: Medieval denomination of the private chapel of the popes nested in the *Patriarchium* residence. The chapel was built to house multiple relics, the most popular of which is still today the *Acheropoieton* image of Christ, a 13th century icon venerated by popes and carried in procession during the day of the

Assumption (August 15) from the Lateran to the Basilica of Santa Maria Maggiore.

- SCALAE PILATI: The traditional name was used until the Renaissance to historicize the sanctity of the Holy Steps, by asserting that it previously belonged to the palace of Pontius Pilate in Jerusalem.

- STIMA: The *Stima dei Lavori* is an itemized estimate of the phases of a project that describes costs, materials, and artists involved in the construction and decoration of a building.

# LIST OF ILLUSTRATIONS

# ACKNOWLEDGMENTS

Foremost, I would like to express my sincere gratitude to my adviser, Professor Elinor Richter, for the continuous support of my study and research. Her lectures always enchanted me and her mastery of Renaissance art is an invaluable resource for anyone interested in learning "how art history works" at the deepest level. Professor Richter is the kind of scholar who initiates the students to the right approach to visual culture and leads them toward the discovery of the inner recesses of the artistic process.

My deep gratitude goes also to Professor Kim de Beaumont. Her strong command of French art inspired me to look back at the art produced in Paris during the late Renaissance period—when many artists went to Rome to learn from the Great Masters such as Michelangelo and Raphael—even before the eighteenth century Grand Tour. I not only have enjoyed conversations in French with her but also explored the possibility to understand the papacy of Sixtus within the broader context of the Protestant Reformation that was so crucial in France at the time of Henry IV, first Protestant king, who embellished Paris in the same period in which Sixtus V was beginning the transformation of Rome into the renewed capital of Christendom.

To my wife, who has always loved, supported, and encouraged me to pursue advanced studies in Art History.

# INTRODUCTION

The Holy Steps are part of the Lateran complex that comprises the Basilica of Saint John in Lateran, cathedral of Rome, and the Lateran Palace, once known as "Patriarchio." The Lateran was the first residence of the popes from the time of Constantine (fourth century AD) until their return from Avignon (1377), after which they began the construction of a new residence in the Vatican.

This research project aims to explain that during the papacy of Sixtus V (1585–1590), Counter-Reformed Rome underwent a significant transformation of its liturgy and of the way in which its religious monuments were approached by the faithful. At the end of the Renaissance period, Sixtus V, aided by the architect Domenico Fontana, carried out many building projects to improve the streets of Rome, to better the access to the main basilicas and churches, and to grant the clergy new processional pathways across the major stational churches. If, in the medieval period, the Holy Steps were used as a private chapel by the popes and as a place where the leader of the Papal States could venerate martyrs' relics that once were in the catacombs, with Sixtus V the complex became a stand-alone building open to anybody seeking penance. Furthermore, the fresco decoration commissioned to the team of mannerist artists, led by Paris Nogari and Cesare Nebbia, emphasizes the devotional aspects of the Passion of Jesus. The Holy Steps's iconography discloses its didactical purpose to be for the pilgrim a Bible of the Poor (*Biblia Pauperum*); that is, a complement for the illiterate who needed to make his visit to Rome worthwhile.

The five years in which Sixtus V governed the Papal States (1585–1590) was an era in which centralization triumphed in the Roman Catholic Church.

According to this view, obedience to hierarchical authority was exalted as the only possible path to eternal salvation; diversity and creativity were smothered by inquisition and censorship. In this context, the arts had an important role in teaching, delighting, and moving Catholic audiences to conduct a life of faith and good works that would lead to eternal life.

In Rome and the rest of Italy, a large number of men and women were believed to be saints and persons who, after death, offered a good example of how to live a Christian life and who functioned as intercessors before God. Saints are well worth the attention of art historians because, like the heroes of ancient Greece, they reflect the values of the culture in which they are perceived in a heroic light. If saints complemented the new decoration of the Holy Steps in Rome commissioned by Sixtus V, the real focus for the faithful visiting the Lateran sanctuary was, in the pope's intention, the veneration of a medieval image of Christ that was believed to have been painted not by human hands (acheropoieton).

According to Ernst Kitzinger,[1] the icon of Jesus was carried in procession since the Middle Ages from Saint John in Lateran during the Feast of the Assumption to the nearby papal basilica of Santa Maria Maggiore, where the popular icon of the *Madonna Salus Populi Romani* was venerated, as a metaphoric embrace and rejoicing between mother and son. Furthermore, with Sixtus V, the sacred image of Christ preserved at the Holy Steps became a polemical instrument against the Protestants, who had argued against the real presence of the body and blood of Christ in the Eucharist.

Similarly, the fresco decoration commissioned by Sixtus at the Holy Steps is intentionally amended of all mythological and grotesque elements, since it focuses not only on the Divine Revelation, but it also must not distract the eyes of the viewer. If in the same period wealthy cardinals, and even the rigorous Pius IV, decorated private buildings with mythological

---

[1] See Ernst Kitzinger and John Mitchell, *Studies in Late Antique, Byzantine and Medieval Western Art* (London: Pindar Press, 2002), 27–28.

scenes,[2] after the Council of Trent, members of the new reformed Church praised the use of ornaments not for pleasure's sake, but only if contextualized within the sacred story that is represented.[3] What is remarkable is that in the *Scala Santa*, the decorative friezes are replaced by a simple white *trompe l'oeil* grisaille that stresses the importance of the water within the sacrament of christening, when Saint John the Baptist poured it with a shell on the head of his cousin. Although the foundation of the new Church was rooted in the legacy of ancient Rome reenacted by Julius II, the papacy of Counter-Reformed Rome sought in the art of early Christianity the source to revive Christian liturgy and practice. Sixtus's major concern was not only the rejection of paganism but also the correct use of religious images that needed to be programmatic and take into account function, site, and audience.

The function of the images commissioned by Sixtus at the Holy Steps was to stimulate the devotion of the worshippers as they worked their way up, on their knees, to the top. There is little to distract the devout, either within the scene or outside the frame; the focus is held strictly on the principal action. All the ornamental elements around the narratives are reduced to a minimum, because the provisions of the Council of Trent required the sacred images to be true to the scripture, legible, and decent.

On the two flanking staircases, Old Testament scenes describe the sinfulness of humankind and the need for redemption. The cycle begins with *Adam and Eve*, the *Temptation*, and the *Expulsion from Paradise*, followed by *Cain Murdering his Brother*. The side scenes are all traditionally interpreted as prefiguration of Christ and require a deeper intellectual examination;

---

[2] In 1558, Pius IV built the complex of the *Casina* as an antiquarian reconstruction of an ancient Roman Nympheum. Pirro Ligorio was the architect who also supervised the decorative program that emphasized the primacy of the papacy based upon the classical legacy of ancient Rome. See Graham Smith, *The Casino of Pius IV* (Princeton: Princeton University Press, 1977).

[3] See Charles Borromeo *Instructiones Fabricae et Supellectilis Ecclesiasticae* (México, D.F: Universidad Nacional Autónoma de México, 1985), 91–96. In his manual, the Cardinal, nephew of Pius IV, expressed negative opinions about the use of the grotesques in the decoration of sacred buildings. Based on the fact that grotesques were found in buildings that had been buried, like the *Domus Aurea*, he deduced that they were used in antiquity to decorate underground caverns where the devil was worshipped, and that therefore they were considered inappropriate to sacred settings.

they begin at the top of the staircase when the visitor has just finished the ascension of the central staircase on his knees. The central stair recreates the *Via Crucis*, the dramatic reenactment of Christ's suffering along the road to Calvary. Contrary to the Old Testament scenes, the Passion's cycle aimed at generating a spiritual participation in the devout. The central scenes were not designed for contemplation, and the composition is centralized and devoid of superfluous ornaments.

By rebuilding the Holy Staircase and the Lateran Palace, Sixtus intended to replace the dilapidated medieval complex that had served as the papal residence until the Renaissance, during which time popes had already moved to the Vatican. In restoring the Lateran, Sixtus was symbolically renewing the early Christian tradition, in the same way that restoring the obelisks celebrated continuity with classical antiquity. For the pope, the Lateran was not the final stop of the *Possesso* ceremony but the beginning of his direct contact with the people of Rome. Contrary to his predecessor, Gregory XIII, Sixtus intended to play a pivotal role in the public life of the Romans as supreme authority of the Church and as bishop of Rome. As soon as he was elected on May 25, 1585, he proclaimed an extraordinary Jubilee—a practice that had never taken place before, since the ordinary Jubilee was celebrated every twenty-five years—invoking the protection and the assistance of God and opening the city to the arrival of more pilgrims. The year resulted in an experiment, in which the pope was able to test how the Lateran could become a hinge to the itinerary to the Seven Churches of Rome created by Saint Filippo Neri.[4] In fact, Lent has seven Sundays, including Easter Sunday, a number that can be obtained adding up the four Sundays of the Advent, Christmas, Epiphany, and the day of the Circumcision of Christ. However, instead of celebrating these days in the papal chapels of the Vatican like his

---

[4] The Seven Churches of Rome are the four patriarchal basilicas of Saint Peter's, Saint John in Lateran, Saint Paul Outside the Walls, and Santa Maria Maggiore. The other three are churches built mostly on the cemeterial complexes of the Catacombs, such as San Lorenzo Fuori Le Mura and Saint Sebastian, except the basilica of Santa Croce in Gerusalemme, built next to the residence of Helene, mother of Constantine. They are mentioned for the first time by his disciple, the Cardinal Cesare Baronio, in his historical account of the first twelve centuries of the Catholic Church. See Cesare Baronio. *Annales Ecclesiastici* (Barri-Ducis: L. Guerin, 1864), 23–25.

predecessors, Sixtus promulgated the bull *Egregia Populi Romani Pietas* (1586),[5] in which he ordered the cardinals to celebrate masses twenty-six times a year in the stational churches of Rome, since the devotion of the Christian is better shown when a visit to the tombs of the martyrs is made. Therefore, the shift of the *cappella pontificia* from the Vatican to the seven churches of Rome had the purpose of creating a link between late Renaissance Rome and the early medieval times, when popes celebrated their functions with the clergy and the people, as Gregory I and Leo the Great had already done in the past. As a result, to facilitate access to the preexisting religious buildings, new roads were created and some of the existing ones were widened to comply with Sixtus's vision of the unity and the harmony of the Church under its pastor.

---

[5] The text of the papal bull is in Gaetano Moroni. *Dizionario di Erudizione Storico-Ecclesiastica da S. Pietro Sino ai Nostri Giorni* (Venezia: Tipografia Emiliana, 1840), 161–163.

# 1

# THE COUNTER-REFORMATION
# IN ROME

❧

## 1.1 The Creation of a Global Artistic Language in Late Renaissance Rome

Few periods of the history of the Italian Renaissance art have been highly labeled as the last three decades of the sixteenth century, a period that is commonly called "Late Renaissance Art," "Mannerism," and "Pre-Baroque." Style periodization had traditionally caught the attention of scholars rather than the analysis of the extremely prolific era of patronage, resulting in a complicated and often confusing collection of terms ranging from "Counter-Maniera" to "Anti-Maniera."[1] For one thing, the last three decades of the Renaissance were characterized by the end of the classical style introduced in Rome by Raphael; for another, the period that covers the pontificates of Gregory XIII (1572–1585), Sixtus V (1585–1590), and Clement VIII (1592–1605) was an age

---

[1] The problem of the periodization of the styles at the end of the Renaissance is discussed by Marcia Hall in her volume *Rome* (New York: Cambridge University Press, 2005), 12–14. Hall chooses to abandon some of the terms but to retain others, such as "Counter-Maniera."

of major painting cycles and architectural projects in Saint Peter's Basilica and in Saint John in Lateran as well.

The late Renaissance was a clear paradigm of the crucial role played by the visual arts in the service of religion when, after the Council of Trent (1545–1563), the Catholic Church seems to have redefined its relationships to the arts, still borrowing from the past but experimenting with new styles and iconographies at the same time.

The present research will try to move beyond the stylistic labels and look at the art itself from the point of view of the people of that time, such as its makers, patrons, and audience. The people who lived in the late Renaissance did not look at the formal and stylistic qualities in the works of art as we do today, nor did they conceive the art of their time in terms of large periodizations.[2] For many later sixteenth-century people, especially clerics and members of the religious orders, a good work of art was an effective one, since quality was much more a concern of the courtly elite, for example in the cases of a papal palace or a cardinal's residence. For most Italians, a holy picture was primarily just *arte sacra*. Beginning as early as 1530 in Rome with the works of painters such as Daniele da Volterra and his *Descent from the Cross* (fig. 1), artists began to revolutionize sacred painting with a new emphasis on spirituality and mysticism, clarity and accuracy. The use of emotions (*affetti*) moved the spectator to a new spiritual dimension that marked a change from the prevailing Maniera style with its cool artifice and ornament. Since the primary aim of the art produced for the religious building in Rome was to communicate with the widest possible audience, artists creating images necessarily aimed at a universal style based on classical rhetorical principles of clarity, restrained emotion, and visual delight through color.

The purpose of the *arte sacra* created at the end of the Renaissance was also the desire to return to styles associated with the past, especially a kind

---

[2] The dangers implicit in the periodization of the styles were already discussed by E. H. Gombrich in 'Norm and Form: The stylistic categories of art history and their origins in Renaissance ideals,' published in *Norm and Form, Studies in the Art of the Renaissance* (New York: Phaidon, 1971), 81–98. He evoked the scholastic habit that there is an epistemological need to classify works of art and that the whole armature of stylistic terminology rests upon normative criticism, which depended upon the fundamental polarity between classic and non-classic.

of updated Byzantine or medieval manner of painting reminiscent of the mosaics and icons of the early Christian basilicas. This antiquarianism anticipates a Roman obsession with its early Christian past that would reach its peak at the time of Sixtus V, who transformed the Holy Steps from a mere medieval porch entrance to the Lateran Palace into a public sanctuary where the faithful could pray on their knees all the way up, until they could see the medieval icon of the Savior. These primitive styles and the attention to the pre-Renaissance period attracted artists and patrons, because these people believed that their spiritual authority was more intense and their iconography more correct, and their degree of ideological persuasion was greater than the mainstream styles of the later Cinquecento. The antiquity of pre-Renaissance styles lent them a special fascination that was permeated with a mysticism derived from their association with the saints and miracles of a period considered a heroic era for the Church.[3]

In general terms, sacred images were cultic objects, considered to be the visible manifestation of the sacred person. On the other hand, these images were painted by known artists and participated in the aesthetic and stylistic rules of the Renaissance, at the end of which the image's effectiveness was more important than its role as a work of art. In such works, the task of art was merely to refashion these authentic cult images from the past and present them to their new audiences with appropriate dignity.

## 1.2  The Return to the Cult of Saint Stephen under Pius V

The impetus for a cathartic renewal and a return to the protomartyrs' cult found in the predecessor of Sixtus V, Pius V, a strong representative. Cardinal Michele Ghislieri was a Dominican friar and Inquisitor General before becoming a saint after his death. He was elected pope in 1566 taking the name of

---

[3] In 1600, Cardinal Cesare Baronio, ecclesiastical historian of the Church of Rome, restored in early Christian style the church of Santi Nereo ed Achilleo. His methods and the sources he used are discussed in Alexandra Herz, "Cardinal Cesare Baronio's Restoration of SS. Nereo ed Achilleo and S. Cesareo de'Appia." *The Art Bulletin* 70, no. 4 (December 1, 1988): 590–620.

Pius V. A zealous reformer and a strictly religious man, he was known for his asceticism and a particular devotion to the Passion of Christ. As pope, he worked to reform the Church in accordance with the Tridentine decrees, and he promoted with Venice and Spain a league that defeated the Turks in 1570. Although Pius V was an enemy of pagan antiquity for having decided to remove all the pagan statues from the Belvedere Court,[4] he sponsored several projects during his pontificate. Since Michelangelo had just died in 1564, Pius appointed Giacomo Barozzi da Vignola (1507–1573) as chief architect of Saint Peter's Basilica in 1567, because he was eager to move forward with the works. Pius promoted activities in the Vatican palaces as well. He added a third story to its western wing and erected the *Torre Pia* adjacent to the *Cortile della Sentinella*, where the Swiss Guards greeted heads of states visiting the pontiffs. The tower had three chapels built within a five-story building, one above the other. All three were conceived as oval in plan, topped by a dome, and were decorated by Giorgio Vasari (1511–1574) between 1570 and 1571. The Chapel of Saint Stephen occupies the ground floor and was intended for the use of the Swiss Guards. Four scenes from the life of the protomartyr cover the walls: his preaching, the healing of a cripple, his distribution of alms, and his burial. The Trinity and an angelic choir adorn the dome. The altarpiece of the chapel was decorated with a painting by Vasari representing the *Stoning of Saint Stephen* (fig. 2), now in the Pinacoteca Vaticana.

The chapel above is the Chapel of Saint Peter of Verona.[5] Originally reserved for the members of the papal household, its decorative scheme is similar to the Chapel of Saint Stephen. On the walls are frescoes depicting four episodes of the life of the saint, and the dome shows the triumph of the Church over the heretics, accompanied by allegorical figures of the theological virtues and portraits of Dominican saints. The third and uppermost chapel was dedicated to Saint

---

[4]  Francis Haskell and Nicholas Penny. *Taste and the Antique : The Lure of Classical Sculpture, 1500–1900* (New Haven: Yale University Press, 1981), 67–72.

[5]  Saint Peter of Verona does not need to be confused with Saint Peter, apostle of Jesus. Saint Peter of Verona (1206–1252) was a Dominican friar and preacher who fought against the doctrine of Catharism, a form of dualism that rejected the authority of the Pope. An excellent biography is in Gianni Festa, *Martire Per La Fede: San Pietro Da Verona Domenicano e Inquisitore*. Domenicani 29 (Bologna: ESD, 2007).

Michael and was the private chapel of Pius himself. Although little of its decoration remains, Vasari left a detailed description of its program.[6] In the dome were the seven archangels struggling against the seven mortal sins, and at the corner of each dome there were four *tondi* representing the *Birth of Christ*, the *Annunciation*, *Zacharias and the Angel*, and the *Liberation of Saint Peter*. The lunettes above the doors were painted with the Doctors of the Church, among which the Dominican Saint Thomas Aquinas was shown defeating the heretics, and the four Evangelists.

It is worth noting that the iconographic program of the Torre Pia is emblematic of the attitudes of Pius V toward art and patronage. First priority for this pope was the creation of a place for prayer and meditation; second, the choice of placing the chapels within a tower overlooking the Belvedere Court may be seen as reflecting his desire for the sacred to dominate the profane. Furthermore, his filling the chapels with images of saints and martyrs is tangible proof of his belief in the value of Christian art to instruct and move the faithful toward a holier life. Equally indicative of the pope's culture and education is the selection of the saint patrons of the three chapels. The protomartyr Saint Stephen was the first to die for the faith and was viewed as a cornerstone of the Roman Church. Saint Peter of Verona was, like Pius, a Dominican and Inquisitor General and was considered the most important Dominican saint after Saint Dominic and Saint Thomas Aquinas. Famous for his preaching and his fight against the Cathar heresy, he was used as a model during the Counter Reformation.[7] Saint Michael, on the other hand, is the protector of the Church Militant in Christendom and adversary of Satan, impersonated by the Protestants. In addition, Pius's V original name when he was cardinal was Michael, an association that makes clear the message he wanted to embed in the iconographic program of the chapel.

---

[6] In his *Le Vite* (pp. 480–482), Vasari describes first that under the pontificate of Pius V, no major commissions were carried out in Rome, but Pius asked him to decorate his private chapels and to make drawings for his tomb in the church of Santa Croce in Bosco, near Milan, city of Pius's birth. The artist also specifies that he gladly accepted the commission of the pope while he was still working in Florence on the fresco decoration of the *Salone dei Cinquecento*.

[7] On the rising importance of the role of preaching following the Council of Trent, see Frederick J. Mc Ginness, "Preaching Ideals and Practice in Counter-Reformation Rome." *The Sixteenth Century Journal* 11 (July 1, 1980): 109–127.

Another project carried out by Pius V outside of the Vatican was the new facade of the north transept of Saint John in Lateran, which would anticipate major interventions of his successor Sixtus V. Although the main entrance of Saint John is located to the east, it was through the north transept—which faces the city and the basilica of Santa Maria Maggiore—that most visitors entered the basilica.[8] Pilgrims in the Middle Ages entered the basilica through the transept whose facade was already decorated with twin brick bell towers. Pius V retained the original medieval facade, resurfaced the bell towers with white stucco, and joined the campaniles with a masonry bridge (fig. 3). These very small interventions reveal the extent to which the Lateran was viewed as precious relic of the early Church, worthy of preservation.[9] The decision to preserve the structure of the cathedral of Rome and not to add more to the existing complex rested on the Franciscan and Dominican literature, and in particular in the writings of Saint Bonaventure, who wrote in his *Legenda Maior*[10] that Saint Francis had appeared to Pope Innocent III in 1216 supporting the falling Lateran, an episode that was painted by Giotto in the nave of the Basilica of Saint Francis in Assisi (fig. 4).

Ultimately, the rehabilitation of the Lateran's fabric and the contemporary reassertion of its preeminence were powered by the intention to restore the spiritual primacy that the Lateran had possessed during the first age of Christian triumph under Constantine. The repairs would have evoked the great spiritual renewal of the Church then being concluded in the final sessions of the Council of Trent, which had just been terminated in 1564 under his predecessor Pius IV.

---

[8] Sixteenth-century descriptions of the Lateran make explicit that the transept portal functioned as the main entrance to the church. The sixteenth century monk Mariano da Firenze reported in his *Itinerarium*, 148, "Ad istam ecclesiam communiter ingrenditur per ostium quod est in fronte sinistri lateris crucis ecclesiae" (Into this church normally someone enters through an entrance located in front of the left side of the transept) [Translation by the author].

[9] Pius V issued on December 21, 1569, a bull in which he placed the entire force of his Apostolic authority behind the Lateran's supremacy over Saint Peter's. The text of the bull is in the *Bullarum Basilicae Vaticanae*, 3:72–5.

[10] For the Bonaventura's text see Ewert H. Cousins, *Bonaventure, The Life of St. Francis* (San Francisco: Harper, 2005), 133–135.

## 1.3 Non- Papal Patronage: Vignola and the New Church for the Jesuits in Rome

Religious orders played a significant role in church building and in the urban renewal of Rome during the Cinquecento. After Franciscans and Dominicans, the Society of Jesus had its newborn order officially approved by Paul III Farnese in 1540. Following the death of its founder, Ignatius of Loyola, in 1556, the Jesuits felt the need to move their operations from the small church of *Santa Maria della Strada* on Via degli Astalli. Ignatius already envisioned plans for a new church, but the works never started because of limited funds and the difficulty in acquiring property rights for the land. Finally, in 1565, under the auspices of the wealthy grandson of Paul III, Cardinal Alessandro Farnese, the construction of the new church, the *Gesù,* started with the appointment of Vignola as official architect of the construction site. It was, however, clear since the beginning that the Jesuits had no role in determining its design and position; Vignola was already the official architect of the Farnese family, and he had to follow the instructions of his patron.[11] Cardinal Farnese demanded that the new church's nave had to be vaulted rather than having a flat ceiling and determined that the facade would be oriented toward the *Via Papale*, the processional route that linked Saint Peter's to Saint John in Lateran. Vignola's final design for the church consisted of a church plan with a single, wide nave, shallow transepts, and a series of side chapels linked by interconnecting passages (fig. 5).

The facade of the church is divided into two sections. Six pairs of pilasters with Corinthian capitals divide the lower section from the upper section that has four pairs. The upper section is joined to the lower section by a volute on each side. The main door stands under a curvilinear tympanum, while the two side doors are under triangular ones. Above the main door one can see a shield with the christogram IHS, representing the Latin version of the first three letters of the name of Jesus in Greek, iota, heta, sigma.

---

[11] For the relationship between Cardinal Alessandro Farnese and Vignola see Clare Robertson *Il Gran Cardinale: Alessandro Farnese, Patron of the Arts* (New Haven: Yale University Press, 1992).

Two statues of Saint Ignatius preaching to the nonbelievers flank the central paired pilasters. Finally, a dome capped the intersection point of the transept. *Il Gesu'* was characterized by clarity and simplicity, as it embodied the Counter-Reformation ideals in church design that emphasized a parallelism of a church plan with the body of Christ. In fact, its wide nave was large enough to accommodate vast crowds and was suitable as a hall for preaching, an element that was addressed in the sessions of the Council of Trent.[12] The highly visible and prominent altar serves as a theatrical stage for the celebration of the Real Presence in the Eucharist.[13] The choir area was separate from the nave, emphasizing the distinction between clergy and laity. The numerous side chapels allowed for a number of masses to be celebrated at the same time. In this regard, Vignola's new Jesuit church in Rome complied with all the canons of the post-Tridentine church building, because it focused on the importance of liturgy, ceremony, and preaching in the life of the faithful going to church. Its design became a template for future churches, such as the nearby *Santa Maria in Vallicella*, home to another charismatic saint of the Counter-Reformation: Saint Philip Neri.

## 1.4  The Gregorian Chapel in Saint Peter's Basilica

Although Pope Gregory XIII, predecessor of Sixtus V, carried out several artistic projects in Saint John in Lateran—such as the construction of a road from the north of the basilica to *Porta San Sebastiano*, establishing the Lateran as the center of a system of radiating streets—his major commission, intended to recapture the early Christian past, was the Gregorian

---

[12] The council's canons related to the new architectural principles of the Counter-Reformation are discussed in Henry Joseph Schroeder *Canons and Decrees of the Council of Trent* (St. Louis, Missouri: B. Herder book Co., 1950), 48–50.

[13] Father Thomas Lucas of the Jesuit University of San Francisco is one of the society's experts on St. Ignatius and Jesuit architecture. In Thomas Lucas, *Landmarking: City, Church, and Jesuit Urban Strategy* (Chicago: Jesuit Way, 1997). 34–45, he explains, "The significance of Jesuit architecture was not its novelty, but its functionalism. Jesuit churches take earlier elements and make them into a practical package which emphasizes Church teachings, as defined by the Council of Trent."

Chapel, located in the northern side of the transept in Saint Peter's Basilica. The chapel is L-shaped in plan and consists of a square, topped by a dome, and two adjoining smaller naves, which extend toward the transept and the central nave. For its large dimensions, the chapel can be considered a stand-alone building, in that it measures about 230 feet high from the pavement to the top of its lantern.

In 1575, soon after its construction began, the pope decided that the chapel would also house his tomb. Three years later he consecrated the chapel to both Saint Gregory Nazianzus and to the Virgin Mary, both honored in a single altar (fig. 6). Giacomo della Porta, who became the official architect of the new Saint Peter's after the death of Vignola, in 1573, and the main supervisor of the Gregorian Chapel, created for the pope an elaborate tabernacle above the altar, consisting of two *verde antico* columns supporting a broken pediment, from which springs an attic, capped by another pediment flanked by white marble angels. The figurative decorations were designed by Girolamo Muziano in 1578, and for their creation the pope strategically decided to use mosaics, the traditional medium used in early Christian decorations and specifically recalling Old Saint Peter's. At the altar's center, between the columns, Gregory installed the *Madonna del Soccorso*, a twelfth-century image of the Virgin, which he personally transported into his chapel from the Oratory of Saint Leo in the old basilica on February 12, 1578.[14] By placing the medieval shrine in the new setting, the image appeared almost encased in a multicolored marble reliquary, contributing to the development of a new type of altar-tabernacle that proliferated in Rome during the post-Tridentine period to house venerable Marian icons. It also expressed the Church's belief in the efficacy of such images against the attacks of the Protestants.[15]

---

[14] Paschal II (1099–1118) commissioned the image of the Madonna and Child later known as the Madonna del Soccorso for the altar of St. Leo in the transept of the Old St. Peter's. The fresco was detached from the wall in 1579, and the altar was torn down in order to make room for the new altar of Gregory XIII.

[15] The significance of the late Renaissance altars built to house early Christian relics or sacred images is discussed in Warnke Martin, "Italienische Bildtabernakel Bis Zum Fruhbarock," *Munchner Jahrbuch Der Bildenden Kunst* 19: 61–102.

Two years later, in June 1580, Gregory transported the relics of Saint Gregory Nazianzus[16] from the convent of Santa Maria in Campo Marzio into his chapel, where they were reinterred in an urn below the altar, thus completing the altar. The construction and the decoration went on until 1592, and the altar of the Cappella Gregoriana became not only the first permanent altar of the New Saint Peter's, but it also set the stage for the refashioning of the chapel of the Sancta Sanctorum by Sixtus V, since altars displaying reliquaries posited themselves as patterns of continuity between the Renaissance popes and their medieval predecessors.

The *Madonna del Soccorso* was one of the first altars in Renaissance Rome to be entirely formed of colored marble; all of its surfaces, walls, and pilasters are veneered in panels of precious stone, many of which were taken from ancient monuments. This form of decoration had been employed originally in the Roman Pantheon and was revived by Raphael in the Chigi Chapel in Santa Maria del Popolo (fig. 7). As discussed before, the Chapel of Saint Michael in the Torre Pia, built by Pius V, was also decorated with colored marbles *all'antica*; all these shimmering works of art were viewed, in the context of the Counter-Reformation, as legacy emanating from the early Church and, for this reason, worthy of being emulated. Furthermore, the luxurious and durable form of decoration employed in these chapels reflected the post-Tridentine attention of the Church of Rome to historicize its past and to evoke associations with early Christian monuments.

---

[16] The transportation of the relics of Saint Gregory of Nazianzus needs to be contextualized within the concern and the desire of the pope to see both the Greek Church and the Church of Rome in harmony after the fall of Constantinople in 1453 at the hands of the Ottomans. In addition, Louise Rice explains that there is also a specular motivation of Gregory to have in the basilica both the relics of Gregory the Great (father of the Latin Church) and the ones of Saint Gregory Nazianzus, Father of the Greek Church. See Louise Rice, *The Altars and Altarpieces of New St. Peter's: Outfitting the Basilica, 1621–1666*. (Cambridge University Press, 1998), 25–28.

## 1.5  The Influence of Two Counter-Reformed Texts on the Late Renaissance Art

The art of the Counter-Reformation in Rome was influenced by two major texts. The first was the *Instructiones Fabricae et Suppellectilis Ecclesiasticae,*[17] written in 1577 by the archbishop of Milan, Cardinal Charles Borromeo, and the second one was the *Discorso Intorno alle Immagini Sacre e Profane,*[18] written in 1582 by Borromeo's friend, the reformer Gabriele Paleotti, bishop of Bologna.

The instructions of Borromeo discussed in detail ecclesiastical architecture and its furnishing, providing detailed instructions about site, plan, facade, roof, pavements, and doors. For example, Borromeo recommended that the floor of a religious building be covered with inlaid marble or mosaics, but no image or cross should be placed on it, as the faithful were not permitted to step on the images; they could only venerate them. The doors of the churches needed to be as many as the entrances to the building and could not be similar to the arched gates of the city. The windows had to be built just below the roof to exploit as much as possible the sunlight and also to keep away curious onlookers from the celebrations: those who were outside were not to look inside, but they would be welcomed to pray in the church.[19] Borromeo stated that the choir needed to be located beyond the main altar, as in the early Christian churches, and iron gates would divide the clergy from the faithful. The cardinal continued to postulate that, according to the Tridentine provisions, the tabernacle containing the Holy Eucharist had to be positioned in the main altar, at the center of the church. The tabernacle was to be sculpted in marble with episodes of the Passion of Christ, but inside of it a wooden case, made of poplar, would protect it from the dampness of

---

[17]  Charles Borromeo. *Instructiones Fabricae Et Supellectilis Ecclesiasticae.* 1a ed. Estudios y Fuentes Del Arte En México / Instituto De Investigaciones Estéticas 49. (México, D.F: Universidad Nacional Autónoma de México, 1985).

[18]  Gabriele Paleotti. *Discorso Intorno alle Immagini Sacre e Profane (1582)* (Città del Vaticano: Libreria Editrice Vaticana, 2002), 45-68.

[19]  *Instructiones*, pp. 23–24.

the marble, such as the one created by Leo III in the ninth century for the *Sancta Sanctorum*.[20] The relics of saints would be located in an urn under the main altar, as in the early Christian churches, but if the church owned the head of a saint, that head would need to be encased in a head or bust-shaped reliquary representing the effigy of the saint.[21]

As Paola Barocchi pointed out, the *Instructiones* originated from a type of literature flourishing during the Counter-Reformation with the goal of instructing the faithful on how to behave properly within a sacred space, and aimed, on the other hand, to guide the architect who received a commission from an ecclesiastical patron. In addition, the importance of this text is that it was the only one that applied the Tridentine canons to the sacred architecture.[22]

The second text that extended the Tridentine laws to the arts was the *Discorso Intorno alle Immagini Sacre e Profane,* written by Paleotti a few years before the beginning of the pontificate of Sixtus V. The bishop of Bologna presented a strong defense of the images, arguing that the Council of Trent was the only religious and legal authority to instruct the faithful on the correct use of the religious images. In fact, the Bolognese argued that, on the one hand, for many years images had been destroyed by the heretics, and that, on the other hand, Catholics had a distorted view of the sacred effigies as well. According to Paleotti, sacred art prepared the viewer for catechism and for the correct understanding of the sacraments that communicate the integrity of the message of the Church.

Moreover, he compared the painter to the orator (*ut orator pictor*), who used decorum to achieve the result of instilling devotion on the onlooker. Since the painter was required to know all the different techniques and needed to be versed in iconography, he was considered an intellectual who would deal with the appropriate category of intellectuals when it was time to discuss the function and the iconography of an artistic commission.[23] Although the patron

---

[20] *Instructiones,* pp. 32–33.

[21] *Instructiones,* pp. 50–51.

[22] The thesis is in Paola Barocchi. *Trattati d'arte del Cinquecento, fra Manierismo e Controriforma.* (Bari: G. Laterza, 1960), 67–69.

[23] *Discorso,* pp. 46-48.

would control the content of the artistic expression, the painter would use decorum to link artistic intentions and rules dictated by the patron in order to obtain the final imprimatur on his work, according to the dispositions issued in the Council of Trent. The decorum should not interfere with the ornaments that were criticized in the XXV Session of the Council of Trent in 1566. In line with the provisions about the unnecessary embellishments in sacred painting, Paleotti redistributed the burden of responsibility between the artist, who had the right to depict *grotteschi* as long as the representations were not originating from the imagination, and the spectator, who did not have the right to condemn pictorial artifice as seductive if it had a counterpart in nature.[24] The artist himself would need to be appointed as such by the Church, such as in ancient times when Alexander the Great established that Apelles was to be the only artist admitted at court to portray the king of the Macedonians. The image created by the artist would follow the rule of the *muta predicatio*, which used art to transcend the barriers of language and literacy and help the audience recall and relate to what was said during specific sermons.

Paleotti's text attests to the critical values that the Church of Rome actively endorsed. His treatise is also a remarkable early attempt to devise a general theory of art, because he believed that painting represents the objects *dal vero*, just as the eye experiences nature in direct vision, and is a universal language that can spread Christian stories across all the nations of the world.[25]

---

[24] *Discorso*, pp. 51-52.

[25] Paleotti championed the use of the easily understandable *Sermo Humilis* which, through the arts, could reach the newly discovered continent via the Jesuit and Franciscan missions (op. cit., 54–55).

## LIST OF IMAGES CHAPTER ONE

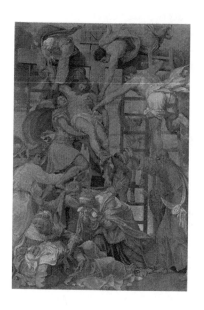

Figure 1: Daniele da Volterra, *Descent from the Cross*, fresco, Chiesa Santissima Trinità dei Monti, 360 x 280 cm, Rome (1545).

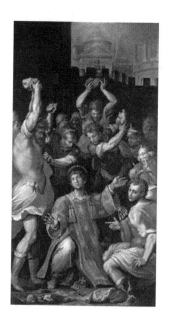

Figure 2: Giorgio Vasari, *Stoning of Saint Stephen*, oil on canvas, Pinacoteca Vaticana, 300 x 163 cm, Rome (1571).

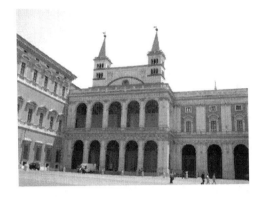

**Figure 3**: *North East Façade of the Transept in Saint John in Lateran and Bell Towers restored by Pius V*, **Rome (1571).**

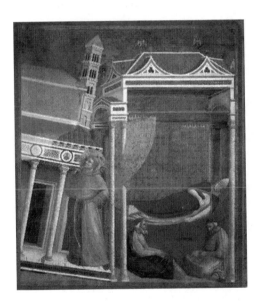

**Figure 4**: Giotto, *Dream of Innocent III*, fresco, Basilica of Saint Francis, Assisi (1298).

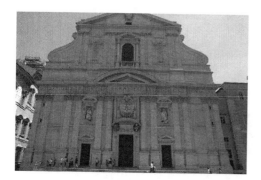

Figure 5: Giacomo Barozzi da Vignola, *Facade of the "Gesu'"* travertine, Rome (1575).

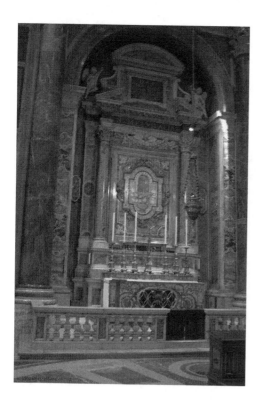

Figure 6: Giacomo della Porta, *Altar of the Madonna del Soccorso*, Cappella Gregoriana, Saint Peter's Basilica, Rome (1580).

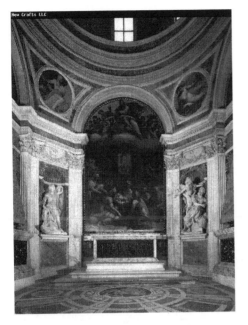

Figure 7: Raffaello Sanzio, *Chigi Chapel*, Santa Maria del Popolo, Rome (1511).

# 2

# URBAN RENOVATION IN THE *ROMA FELIX* OF SIXTUS V

❧

## 2.1 The Building Activity of Sixtus V in Rome

The refashioning of the Holy Steps at the end of the Cinquecento cannot be fully understood if it does not take into account the urban renovation promoted by pope Sixtus V. On April 1585, Cardinal Felice Peretti, a Franciscan friar and preacher from Montalto, was elected pope. He chose for himself the name Sixtus V in honor of two of his predecessors: Sixtus IV, who had also belonged to the Franciscan order, and Pius V, his mentor, who had raised him to the cardinalate and whose papal name also included "the Fifth." Sixtus was an extraordinarily energetic and ambitious pope, who during his five years of pontificate restored the Papal States to economic stability, cleaned the streets from banditry, and planned a final crusade against the Turks with the goal of liberating the Holy Sepulcher and transporting its relics to Italy. Within the Church itself, he enforced the Tridentine decree that bishops should reside in their sees and visit Rome regularly. He also reorganized the College of Cardinals and canonized the first new saints in sixty-five years. In addition, Sixtus undertook a systematic program of devotional plans, including the

proclamation of an "extraordinary" Jubilee in 1585, the revival of stational masses, and the practice of visiting the seven pilgrimage churches in the papal capital (*Sette Chiese*).[1]

Sixtus was also one of the great Renaissance builders, who in the course of his papacy built and decorated numerous churches, chapels, palaces, fountains, and public monuments, as well as rationalized and expanded the urban plan of Rome. By undertaking his renovation of Rome, he intended to project the city as a symbol of triumphant Catholicism, and a bastion of faith strengthened by the purification enacted in the sessions of the Council of Trent. The eye-witnessed account of the Benedictine abbot Angelo Grillo visiting Rome after the pope's death attests to the massive building projects carried out by Sixtus.[2]

Sixtus V had in mind the creation of Rome as the holiest city in the world, and in order to accomplish his mission, he decided to enhance the mystical experience created by visiting the *Sette Chiese*. The Franciscan pope was convinced since the beginning of his pontificate that Rome needed more infrastructures to facilitate the pilgrimages and the papal processions. In 1585, he embarked on a vast campaign of urban transformation, creating a network of broad and paved streets linking the major churches of the city. The Strada Felice (named after the pope) was the central artery of the network, running straight from Santa Croce in Gerusalemme to Santa Maria Maggiore. Furthermore, the creation of Via Panisperna linked the Viminal to the Esquiline Hill, running from Santa Maria Maggiore to the station church of San Marco. The Strada San Giovanni connected the Lateran to the Colosseum and the Via di Porta

---

[1]  The pilgrimage to the *Sette Chiese* in Rome was created by Saint Filippo Neri in 1561 with the goal of getting the faithful to know better the mysteries associated with Passion of Christ. The visit could be made in two days. In the first day, the pilgrim could visit Saint Peter's Basilica, and in the second day he could go to the other six churches, Saint John in Lateran, Santa Maria Maggiore, Saint Paul Outside the Walls, Saint Lorenzo Fuori le Mura, Saint Sebastian, and Santa Croce in Gerusalemme. A complete historical account is in Gabriele Guarrera. *Via delle Sette Chiese in Roma : un Percorso Storico, Archeologico, Paesistico.* (Roma: Gangemi, 1997).

[2]  Ludvig Von Pastor, in *The History of the Popes from the Close of the Middle Ages. Drawn from the Secret Archives of the Vatican and other Original Sources.* (St. Louis: Herder, 1898). XXII. 305 describes the surprise of the Benedictine abbot in seeing Rome transformed. See excerpt of the text in appendix, text 7.

San Lorenzo was created to link the basilicas located in the eastern side of Rome: Santa Maria Maggiore and San Lorenzo Fuori Le Mura. All the roads created and repaved by Sixtus were part of a network of streets radiating from the pope's most beloved church, Santa Maria Maggiore (fig. 8), whose Sistine Chapel would house his remains in 1590.[3]

Another impressive undertaking by Sixtus was the repositioning of four ancient Egyptian obelisks, which had been brought to Rome by Roman emperors after the annexation of Egypt as new province of the Roman Empire. The first to be raised was the massive granite obelisk from Heliopolis, which had been set up by Caligula on the *spina* of the Circus of Gaius in 39 AD (*Circus Gai*).[4] There it stood for more than fifteen hundred years witnessing, according to tradition, the martyrdom of Saint Peter and the construction of his basilica adjacent to the circus. In the middle of the fifteenth century, Nicholas V had envisioned the idea of moving the obelisk from the south flank of Old Saint Peter's to the center of a renovated piazza in front of the basilica's facade, but the project was never carried out. The idea of moving the obelisk was taken up again by Pope Paul II and by Gregory XIII but each ultimately rejected it as impossible to achieve. Within months of assuming the papacy in 1585, Sixtus V resolved to carry out the plan to re-erect the Vatican obelisk, entrusting Domenico Fontana with the project. The colossal enterprise, described in Fontana's own *Della Transportatione dell'Obelisco Vaticano* [5] involved nine hundred men and seventy-two horses, dozens of cranes, and miles of ropes. After more than four months of intense labor, the

---

[3] The Sistine Chapel in Santa Maria Maggiore does not have to be confounded with the Chapel built in the Vatican by Sixtus's predecessor, Sixtus IV in 1475. The chapel was designed by the same architect who refashioned the Holy Steps, Domenico Fontana, and decorated by Cesare Guerra with a cycle dedicated to the Virgin, whose divine maternity has been questioned by the Protestants. A complete account of the motivations that compelled the pope to build it and of the reasons that inspired its iconographic program is in Steven F. Ostrow, *Art and Spirituality in Counter-Reformation Rome: the Sistine and Pauline Chapels in S. Maria Maggiore* (Cambridge: Cambridge University Press, 1996), 121–197.

[4] A complete account of Sixtus's contributions to the urbanization of Rome is in Maria Luisa Madonna, *La Roma di Sisto V. Le Arti e la Cultura.* (Roma: De Luca, 1993).

[5] See Domenico Fontana. *Della Transportatione dell'Obelisco Vaticano.* (Milano: Ed. Il Polifolio, 1978).

330-ton obelisk was finally positioned upon a new pedestal in front of Saint Peter's on September 10, 1586, as it can still be seen today.

The erection of the Vatican obelisk was a deeply symbolic act that expressed Sixtus's desire to consecrate a monument that was seen as pagan, since the Roman emperors brought it to Rome and, on the other hand, tradition believed that at its apex there was the urn with the ashes of Julius Caesar. Tor purify and exorcize the obelisk, the pope organized a procession from Saint Peter's to an altar located in front of the obelisk. A gilt bronze cross was blessed and erected on top of the obelisk; the orb containing the ashes of Caesar was already replaced by *monti* and a star, which are parts of the coat of arms of Sixtus. In its final act, the Vatican obelisk became a victorious symbol celebrating the triumph of the Christian faith over pagan idolatry, as the inscriptions adorning its base state (*Diis Gentium Impiu Cultu Dicatum*).[6]

The other three obelisks that Fontana erected for Sixtus were no less rich in meaning. In the piazza before the northern transept of the Lateran, Fontana erected in 1588 the largest obelisk in Rome, which Constantine's son brought to Rome in 357 AD and set up in the Circus Maximus. Furthermore, before the apse of Santa Maria Maggiore, Fontana placed a smaller obelisk that once stood in front of the main entrance of the Mausoleum of Augustus. And in 1589, at the end of Via Lata (in what today is Piazza del Popolo), Fontana raised another obelisk that had been brought to Rome by Augustus and adorned the Circus Maximus. The four obelisks erected at the end of the new star-shaped network of roads planned by Sixtus thus proclaimed the resurgence of a new Christian Capital, a city dedicated to Christ and ruled by Sixtus, the new Augustus.

After having exorcized Rome with the Egyptian obelisks, Sixtus decided to Christianize two of the most powerful symbols of Imperial Rome: the Column of Trajan and the one of Marcus Aurelius. He first turned his attention to the Column of Trajan in 1587: he ordered that the area surrounding the monument be cleared of the debris; he then topped the column with a colossal gilt-bronze

---

[6]  On the history of the Vatican obelisk and its meanings see Erik Iversen. *The Obelisks of Rome*. (Copenhagen: Gad, 1968), 29–38.

statue of Saint Peter, modeled by Tommaso della Porta and cast by Sebastiano Torrigiani. In the ensuing year, Sixtus restored the column of Marcus Aurelius and placed at its summit a gilt statue of Saint Paul cast by the same team of sculptors. As Domenico Fontana explains, the choice of placing Saint Peter's statue on top of the Trajan column was dictated by the consideration that, if the Trajan Column was dedicated to the most supreme and powerful emperor, now the same monument was going to be consecrated to the Supreme Prince of the Apostles, Vicar of Christ; similarly, as the Antonine Column was dedicated to the great philosopher and scholar Marcus Aurelius, now it was going to be dedicated to a supreme philosopher of the Christian religion, that is, to Saint Paul.[7] The re-erected obelisks and the two Roman columns were integral components of Sixtus's urban plan and functioned as nodal points within the new network of streets. Standing at the ends of major areas and marking important sites within the larger urban landscape, they not only provided visual foci but also served as symbolic *metae* for pilgrims arriving in Rome to visit the tombs of the apostles (*Ad Limina Apostolurum*).[8]

## 2.2 Sixtus's Commissions in the Vatican

After having created the network of roads that linked to one another the main basilicas of Rome, Sixtus began the completion of the dome of Saint Peter's between 1588 and 1590, culminating nearly a century of work on the new basilica. As designed and overseen by Giacomo della Porta, the dome—rising 115 meters above the crossing—presents a more elevated profile than

---

[7] *Della Transportatione*, pp. 34–35.

[8] The expression *Ad Limina Apostolorum* was first used by Pope Zacharias in 743 AD, when he decreed that the bishops nominated by the pope needed to make a visit to the "thresholds of the Apostles" once a year. In the Middle Ages, the term designated simply the visit to the basilicas dedicated to Peter and Paul. With Sixtus V, the medieval expression is enhanced by the bishops' obligation to visit the two basilicas and the pope as well, in order to report to him about the status of the dioceses. The 1588, Sixtus's Constitution, *Romanus Pontifex*, sets the rules for the frequency of the visits to Rome during the Counter-Reformation. In 1994, John Paul II further regulated the matter ordering the visits *Ad Limina* by the bishops every five years.

Michelangelo had originally intended. Despite the alteration, the dome is still today the tallest building of Rome and was completed in only 509 days (fig. 12).[9] The dome crowns the basilica above the tomb of the first pope and stands as symbol of the power and transcendence of Rome and its Church.

Sixtus left his mark on the Vatican as well. In 1586, he had the ground-floor arcade of the Cortile del Belvedere reinforced with pilasters and arches and built a staircase connecting the apartment of his predecessor Pius V to Saint Peter's. Of major importance, however, was the new wing he added to the papal palace, situated on the eastern side of the Cortile di San Damaso. Like the vast majority of Sixtus's buildings, it was designed and constructed by Domenico Fontana, who served the pope as his official architect. By far the most important of Sixtus's contributions to the Vatican, the new wing was begun in 1587 by Fontana to house the Vatican's vast and expanding collection of codices, manuscripts, and printed books. The building accommodated the difference in height between the two parts of the Cortile, by giving the south side, which was lower, one story more than on the north. The library was built in the breathtakingly short time of only six months, and by early 1588, the vast fresco cycle that adorns the interior was started.[10]

## 2.3 Sixtus's Renewal of the Lateran

The renewal of Rome by Sixtus V would have never been really meaningful without a reorganization of the Lateran. Saint John was already the cathedral of Rome since its consecration by Pope Sylvester I in 324 AD, but the popes had already established their residence in the Vatican after their return to

---

[9] An account on the contemporary literature related to Saint Peter's dome is in Rudolf Wittkower, *La cupola di San Pietro di Michelangelo : Riesame Critico delle Testimonianze Contemporanee.* (Firenze: Sansoni, 1964), 113–127.

[10] The frescoes of the Vatican Library can be still seen today while visiting the Vatican Museums. Among them, the cycle of the history of the Lateran Councils is meant to legitimize the historicity of the papal power that in the Middle Ages banned the heresies and could act with the same energy against Luther. See again *La Roma di Sisto V*, pp.112-115.

Rome from Avignon. [11] At the time of Sixtus, however, the basilica of Saint John was mainly used as the center of papal ceremonies, among which the most prominent was the symbolic taking possession of the cathedral of Rome after the pontiffs' election (fig. 10). It was the popes' constant desire to link the new tradition with ancient ceremonies: if in medieval times popes were crowned and enthroned in Saint John in Lateran, once they had set up their residence in the Vatican, they were still crowned in Saint Peter's, but they had to go to Saint John to be enthroned. In 1500, Pope Alexander VI Borgia gave birth to the ceremonial trip of the *Possesso,* where the newly crowned pope rode on a white horse from Saint Peter's to Saint John in Lateran; once arrived at the Lateran, he received the silver and gold keys of the city of Rome. The ride was divided into four parts and recalled the triumphal processions in ancient Rome; the pope, with his attendants, exited first Saint Peter's (*exitus*); he then went up to the Capitol Hill, where in antiquity the triumphs terminated with the sacrifice to the temple of Jupiter Optimus Maximus (*adscensus*); the procession continued downhill and passed under the arches of Septimius Severus, Titus, and Constantine (*descensio*); it flanked the Colosseum and arrived at the Lateran, where the pope was enthroned and received allegiance of the cardinals (*introitus*).[12]

In order to endow Saint John with a building that could reassert the church's singular role as the cathedral of Rome, Sixtus V commissioned the architect Domenico Fontana to demolish the crumbling medieval *Patriarchium Lateranense*[13] and replace it with a structure that could symbolize the papal authority and the traditions associated with it. Fontana initi-

---

[11] Although Gregory XI officially moved the Holy See back to Rome in 1371, pressures from the French king to elect a French pope and from the Roman nobles to have an Italian candidate brought to the Western Schism that concluded with the election of the Italian Cardinal Oddone Colonna in 1417 who became Pope Martin V. On the art in Rome during the Avignone Period see Serena Romano *Eclissi di Roma : Pittura Murale a Roma e nel Lazio da Bonifacio VIII a Martino V (1295-1431).* (Roma: Àrgos, 1992).

[12] The importance of the *Possesso* ceremony as a device to display the papal power is highlighted in Gianvittorio Signorotto and Maria Antonietta Visceglia. *Court and Politics in Papal Rome, 1492-1700.* (Cambridge, UK; New York: Cambridge University Press, 2002), 164–171.

[13] On the history of the medieval *Patriarchium* of Saint John in Lateran see Richard Krautheimer, *Rome, Profile of a City, 312-1308.* (Princeton: Princeton University Press, 1980), 46–58.

ated the tearing down of the old palace in 1586, and by the summer of 1589 the new palace was virtually completed (fig. 11). The palace exemplifies the architecture of Palazzo Farnese; it has a square plan with a central courtyard and an elevation of three stories, each comprised of rooms around a loggia facing the courtyard. It also serves the practical function of housing the pope and his court when visiting the Lateran. Its decorative fresco cycle celebrates the achievements of Sixtus's triumphant pontificate on earth and its reverberation in heaven. The program of the Lateran palace commissioned by the pope embraces Cesare Baronio's anti-Protestant arguments, according to which sacred history was superior to secular history.[14] Furthermore, frescoes depicting the Good Works (*Imprese*) of the pope in Rome, such as the erection of obelisks, acted as example for the common Christian, who may want to do good deeds as well, setting themselves in contrast with Luther, who had said that man could obtain salvation only through faith.[15]

Sixtus's concern for the preservation of vestiges and relics of Early Christianity motivated him to make an exception to the demolition of the old Lateran palace: he decided to preserve the Chapel of Saint Lawrence, known as Sancta Sanctorum—popular for its many relics and for the *acheiropoieton* image of Christ—which served as private chapel of the pope in the palace. The second element spared from Fontana's demolitions was the Holy Steps, or Scala Santa, which functioned as the main staircase leading to the palace and was believed to be composed of the marble steps from the palace of Pontius Pilate in Jerusalem, ascended by Christ before being condemned to death, which was therefore viewed as a precious relic of the Passion.

Although originally quite separate from each other within the medieval palace, Sixtus V decided to join them by moving the Steps to a location

---

[14] Baronio claimed that the authority of the Church and of its vicar have been preordained by God and could be traced back to the Old Testament. See Cesare Baronio. *Annales Ecclesiastici.* (Barri-Ducis: L. Guerin, 1864).

[15] The doctrine of the Justification was one of the main confrontational arguments at the Council of Trent, whose final sessions proclaimed the necessity of faith and good deeds as well to obtain final God's reward. The doctrine is also bound with the Eucharist and explains well the interest of Sixtus in preserving, through the construction of a building-reliquary, the sacred icon of Christ located in the medieval Sancta Sanctorum.

directly on axis with the chapel, sheltering the Steps and the Sancta Sanctorum into a new, single structure. The building would look like a giant reliquary, would be close to the obelisk he had just repositioned, and would be accessed from the road that links Saint John with Santa Maria Maggiore, contributing to the enhancement of the ceremonial pathways and facilitating the access to the religious structures of the Lateran for pilgrims in search of penance.

## 2.4   Preexisting Medieval Constructions Taken into Account by Sixtus and his Architect

The encapsulation of the Holy Steps by Domenico Fontana in the new giant reliquary was affected by preexisting constructions that Sixtus V did not feel worth demolishing. The plan of the Holy Staircase is a Latin cross design that evokes the traditional early Christian basilicas and stems from the Jesuit church Il Gesù. The image in figure 13 shows that the symmetry of the central core of the building is altered on its side wings. The left side of the transept shows the chapel of Saint Lawrence smaller than the chapel dedicated to Pope Sylvester I, located on the opposite side. At the moment of rebuilding the area around the Holy Steps, the Renaissance architect had to factor into account the preexisting pontifical archives (*scrinium*) and the oratory dedicated to Saint Lawrence—the saint considered the guardian of the papal treasures—annexed to the medieval Patriarchium.[16] A first clue about

---

[16] According to the tradition described in *Depositio Martyrum*, written in 354 AD, which contains the principal feasts of the Roman martyrs, Lawrence was a deacon born in Spain who died in 258 AD, following the persecutions ordered by the Roman Emperor Valerian. Saint Ambrose in his work *De Officiis*, mentions that he was in charge of the administration of the Church of Rome under Sixtus II and that he was put to death on a grill. In the sixth century AD, the *Depositio* would be merged into the *Liber Pontificalis*, which describes the lives of the popes from Saint Peter to the fifteenth-century popes. See Ambrose, *De Officiis* (Oxford; New York: Oxford University Press, 2001), 61–62. The main primary source to study the biography of the early popes is the *Liber Pontificalis* edited by Duchesne. See L. Duchesne and Cyrille Vogel. *Le Liber Pontificalis* (Paris: E. de Boccard, 1955).

the existence of the oratory is during the papacy of Stephen III (752–757),[17] followed by the works commissioned by Pope Zacharias (741–752) who built a porch and a bell tower, and protected Christ's *acheropoieton* icon with a gate (fig. 14).[18] The porch was still seen at the time of Sixtus, as depicted in the fresco of Filippino Lippi *The Triumph of Saint Thomas* in the Carafa Chapel in Santa Maria Sopra Minerva (fig. 15) with the bronzed statue of Marcus Aurelius before it. The bell tower, originally built by Zacharias, was restored in the thirteenth century[19] and mentioned in the itemizations of the costs written by Fontana in 1587. To support the evidence found about the medieval bell tower, the *Liber Pontificalis* describes that in 1230 pope Gregory IX (1227–1241) ordered the demolition of the old towers of the Patriarchium after that the earthquake of 1227 had mined their stability.[20]

In the ensuing years, Pope Nicholas III (1277–1280) rebuilt the oratory of Saint Lawrence over the porch of Pope Zacharias, after having filled with bricks all the lintels of the porch. Above the main altar that supports the icon of Jesus, there are two purple colored porphyry marble slabs to help the viewer to focus his attention on the sacred image of Christ (fig. 16). Nicholas rebuilt the chapel with *spolia*, reusing material from earlier buildings, as it is clear from the two supporting columns made of porphyry shown in figure 16. While rebuilding it from the ground up, he planned the decoration of the chapel in function of the liturgical celebrations that were taking place in it. The Mass officiant had in front not only the altar and the icon, but also a mosaic lunette representing the patriarchal cross, flanked by the images of Saint Peter and Saint Paul. In addition, the ceiling above the altar was decorated with a mosaic clypeated portrait of Christ supported by four angels.

---

[17] The *Liber Pontificalis* mentions "Oratorium Sancti Laurentii intra Patriarchium Lateranense" p. 443.

[18] *Liber Pontificalis*, p.442.

[19] The size of the medieval bricks used in the bell tower corresponds to the canonical unit of measurement for a brick in that time which is 22.2 cm. The same size of bricks was used for the construction of the Chapel of Saint Silvester in the church of Santi Quattro Coronati in 1246, as discussed in Daniela Esposito *Tecniche Costruttive Murarie Medievali: Murature "a Tufelli" in Area Romana* (Roma: L'Erma di Bretschneider, 1998), 67–73.

[20] *Liber Pontificalis*, p. 445.

A marble bench surrounding the other three sides of the chapel offered comfortable seats to the popes' chaplains.

A master marble worker under the name Magister Cosmatus headed the workshop involved in the construction of the medieval chapel; his name is still visible in the left wall of the chapel.[21] The exterior appearance of the chapel is visible in the fresco, located in the upper register, depicting Pope Nicholas III between Saint Peter and Saint Paul offering the model of the chapel (fig. 18). Its triforate windows were built with white marble but two of them were just decorative and only the central one would have been responsible for carrying the light inside the chapel, following an architectural pattern that was also employed in the bell towers of the Roman Duecento. The chapel itself is a rectangle measuring seventeen by ten feet; its gothic quadripartite rib vault was frescoed with the four evangelists and was mirrored by a cosmatesque mosaic floor with roundels and squares. Over the inscription, two small side windows contained relics pertaining to the heads of Saints Peter and Paul, some hairs of the Virgin Mary, and remains of the head of Saint Agnes (fig. 18).[22] The arcaded loggia is composed of trilobed windows that are reminiscent of the north transept in the Basilica of Saint Francis in Assisi (fig. 20). Unlike Assisi, however, the Sancta Sanctorum's loggia is in low relief and serves no practical function; it displays full figured prophets and the Virgin Mary.

Another prototype that may have influenced the architecture of the medieval papal oratory is the Saint Chapelle of Louis IX; built in Paris between 1241 and 1248. At the time when the popes were attending the second Council of Lyon in 1274, the French palatine chapel became a model for architects planning a space that emphasized a correct and

---

[21] The text of the inscription by the Magister Cosmatus is "+ MAGISTER COSMATUS FECIT HOC OPUS."

[22] In his 1286 *Historia Ecclesiastica*, the Dominican Ptolemy of Lucca, friend of Saint Thomas Aquinas, describes that the relics were moved by the pope at the time of the inauguration of the chapel from the old wooden chest, commissioned by Leo III in 790 AD, to the windows above the inscription. The text of the *Historia Ecclesiastica* is in Lodovico Antonio Muratori and Filippo Argelati, *Rerum Italicarum Scriptores* (Sala Bolognese: A. Forni, 1977) Vol. XI, 224–311.

efficient location of the relics for liturgical purposes.[23] Like the chapel of Nicholas III, the chapel of Louis IX was externally devoid of any decoration, but its interiors were decorated with expensive materials, and both chapels aimed at extolling the importance of the main relics they contained: the Parisian chapel preserved remains of the True Cross and the Roman oratory housed multiple relics, among which the most venerated one was the sixth-century icon of Jesus.

The pictorial cycle of the chapel consists of panels that are unrelated to one another. Contrary to the main frescoed decorations in the early Christian basilicas, there is no continuous narrative in the panels of the Sancta Sanctorum, and each painting is an anachronistic succession of martyrdom scenes. Each panel is placed on a dark-red background [24] decorated with vegetal motifs painted in grisaille and is meant to illustrate that the continuity of the Church rests upon the martyrs who lost their lives because of their beliefs. Moreover, the frescoes have no didactical intentions and are just celebratory, since until the interventions of Sixtus V the chapel was a private room not open to the public. To the right of the fresco depicting Nicholas offering the model of the chapel, on the altar wall, there is a panel depicting the enthroned Christ flanked by two angels (fig. 21): he is shown with the right palm of his hand toward the offering pope, symbolizing a transmission of power or simply the acceptance of the dedication of the chapel rebuilt for him by the pope. Christ's hieratic figure was exemplified on the icon preserved in the altar below, since the *acheropoieton* was believed to be the authentic image of Christ. On the opposite wall appear the *Crucifixion of Saint Peter* and the *Execution of Saint Paul*. On the east wall are the *Miracle of Saint Nicholas* and the *Martyrdom of Saint Agnes*. The west wall contains the *Stoning of Saint Stephen* and the *Martyrdom of Saint Lawrence*.

---

[23] See Robert Branner, *St. Louis and the Court Style in Gothic Architecture* (London: A. Zwemmer, 1965), 88–90.

[24] Serena Romano argues that the style used by the Cosmati in the decoration of the Sancta Sanctorum is an intentional "revival" of the early Christian style of the Catacombs that stems from classical Roman painting. See Serena Romano, "Gli Affreschi del Sancta Sanctorum" in Julian Gardner, *Sancta Sanctorum* (Milano: Electa, 1995), 48–49.

## 2.5  The Saints' Loggia: Sixtus's Additions to the Medieval Imagery

Between the walls and the rectangular panels commissioned by Nicholas III, the arcaded gallery, painted in late Renaissance style, acts as support of the medieval scenes (fig. 19). If Nicholas III's iconographic program reinstated the idea that the origins of the Church of Rome lie in its martyrs, Sixtus's loggia of saints was not celebrative of the relics contained inside the chapel, but aimed to instruct the viewer that the Late Renaissance theory of saints supports the medieval imagery and symbolizes the continuity of the pope with the works commissioned by his predecessors.

On June 7, 1590, the painters Giovanni Guerra and Cesare Nebbia received a payment of three hundred *scudi*; the same painters received the balance of another three hundred *scudi* on July 28, 1590, for all the works made in the "Fabbrica del Santissimo Salvatore a San Giovanni in Laterano."[25] The frescoes were painted in only one month after the completion of the cycle on the Steps. Despite a restoration of the chapel carried over in 1995 by the main conservation institute of the Vatican (Gabinetto di Ricerche Scientifiche dei Musei e Gallerie Pontificie), the samples of the frescoes analyzed cannot give any clue of the lower layer of medieval frescoes covered by the Renaissance artists.[26] It should be borne in mind, however, that the painters of Sixtus somehow acknowledged the preexisting iconography, since the new frescoes were applied by incision from a cartoon, and the hood of Saint Benedict is unusually triangular, which recalls medieval stylistic conventions. The loggia has three sets of saints: prophets, apostles, and evangelists. On the side above the main altar from the far left there is the prophet Isaiah holding the scroll with

---

[25]  Witcombe's research based on the *Mandati Camerali* (money orders issued by the Cardinal Camerlengo to the papal treasurer with the disposition to pay someone) located in the Archivi di Stato in Rome, focuses on the evidence emerging from the team of artists involved in the decoration commissioned by Sixtus, as well as the materials they had employed. See Christopher Ewart Witcombe, "Sixtus V and the Scala Santa." *Journal of the Society of Architectural Historians* 44, no. 4 (December 1, 1985): 368–379.

[26]  See "Relazione del Gabinetto di Ricerche Scientifiche dei Musei e Gallerie Pontificie" in Julian Gardner. *Sancta Sanctorum* (Milano: Electa, 1995), 270-281.

the inscription *"Ecce Virgo Concipiet et Pariet."*[27] Next to Isaiah follow, with no inscriptions, Saint John the Baptist, the Virgin holding the Child, and Saint John the Evangelist; next, King David with a scroll bearing the inscription *"De Fructu Ventris Tui Ponam Super Sedem Tuam."*[28] At the corner of each side, the two couples of saints are Saint Peter and Saint Paul[29] who are turned toward the *Madonna with Child*; Saints Stephen and Lawrence are on the opposite corners and wear green-colored *dalmatica*, an ancient Roman gown with wide sleeves and two stripes worn at mass by deacons. The north and west sides display the Apostles holding scrolls, the Evangelist with unopened books. Next to the Evangelist, there are the founders of the main medieval religious orders, Saint Dominic and Saint Francis; close to Saint Francis another black-painted figure represents Saint Benedict. The series of images conclude with some of the main theologians of the Catholic Church: Dionysius the Areopagite and Nicholas of Bari, name saint of Pope Nicholas III. The only popes shown in the loggia are Saint Sylvester I, founder of the earlier chapel, and Saint Gregory the Great. Overall, the portraits express the holiness of the place that is witnessed by the gilded mosaic inscription above the main altar.[30] All the people painted in the gallery share in common the consideration of Christ, whose relics are preserved inside the chapel itself, as savior of Humanity, making the chapel a frescoed polyptych about the origins of Christianity.

---

[27] Isaiah 7.1. In Christian iconography, Isaiah is considered the author of messianic prophecies fulfilled by Jesus Christ. In this passage, Isaiah foreshadowed the birth of Jesus from a Virgin.

[28] Book of Psalms 11.133. The text relates to the promise made by God to David that his descendants will occupy his throne. As Jesus is considered a descendant of David, in the Apocalipse (22.16), Saint John the Evangelist writes that Jesus said himself to be, "The root and the posterity of David."

[29] Relics of the heads of Saint Peter and Saint Paul were already venerated in the Basilica of Saint John in Lateran at the time of Pope Sylvester I. During the pontificate of Stephen VII (866–897), the relics were moved to the Sancta Sanctorum. Leo III, at the end of the ninth century, commissioned a chest made of cypress to better preserve them under the main altar of the Sancta Sanctorum. In 1368, Urban V brought them back to the basilica and placed them under the tabernacle located in the main altar, where they currently are. Every Good Friday, the relics were shown to the faithful. On the history of the two relics see Giovanni Marangoni, *Istoria dell'Oratorio di San Lorenzo*. Roma, 1747. 260–266. Full digital text available at http://reader.digitale-sammlungen.de/de/fs1/object/display/bsb10005120_00005.html

[30] Non Est in Toto Sanctior Orbe Locus.

## LIST OF IMAGES CHAPTER TWO

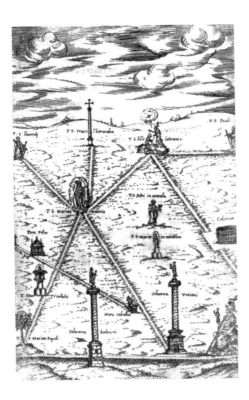

Figure 8: Giovanni Francesco Bordini, *Map of the Radiating Streets Created by Sixtus V*, in his *De Rebus Praeclare Gestis a Sixto V*, engraving (1588).

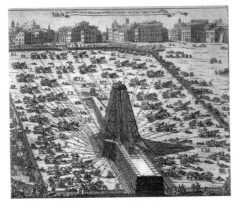

Figure 9: Domenico Fontana, *Repositioning of the Obelisk in Saint Peter's*, in his *Della Transportatione dell'Obelisco Vaticano*, engraving (1590).

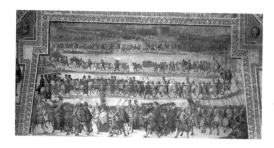

Figure 10: Cesare Nebbia, *Sixtus V Riding from the Vatican to the Lateran*, Fresco, Salone Sistino, Vatican Museums, Rome (1586).

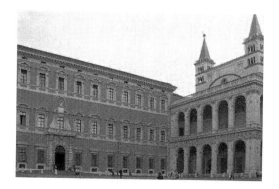

Figure 11: Domenico Fontana, *Lateran Palace (left), Adjacent to the Northeast Transept of the Basilica of Saint John*, Rome (1589).

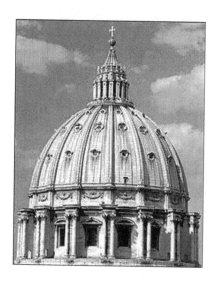

Figure 12: Michelangelo Buonarroti and Giacomo della Porta, *Dome of Saint Peter's Basilica,* Rome (1590).

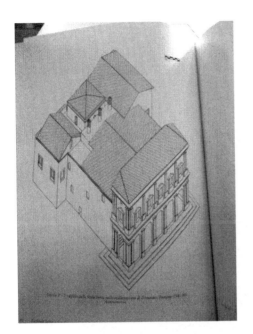

Figure 13: *Elevation of the Holy Steps* (1991). Source: Archivio di Stato Roma.

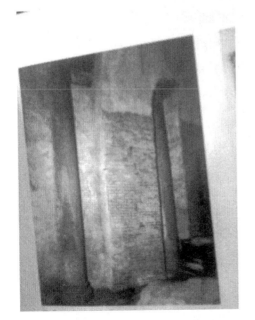

Figure 14: *Two Columns of the Medieval Porch of Pope Zacharias* (741–752).

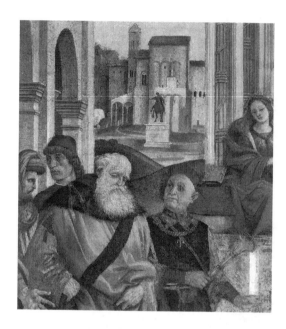

Figure 15: Filippino Lippi, *Triumphing Thomas,* fresco, Carafa Chapel, Santa Maria Sopra Minerva, Rome (1492).

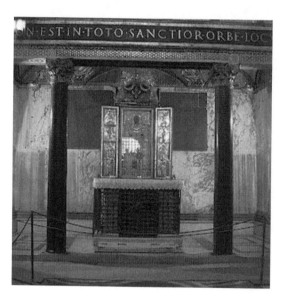

Figure 16: *Interior of the Sancta Sanctorum Chapel with the Acheropoieton Icon of Jesus,* (1279), marble and porphyry, Holy Steps, Rome.

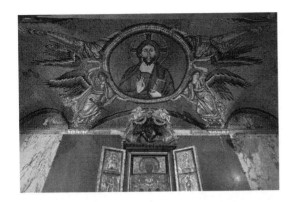

Figure 17: *Ceiling above the Altar of the Sancta Sanctorum Chapel with the Clypeated Image of Christ Supported by Four Angels,* **Mosaic, Holy Steps, Rome (1279).**

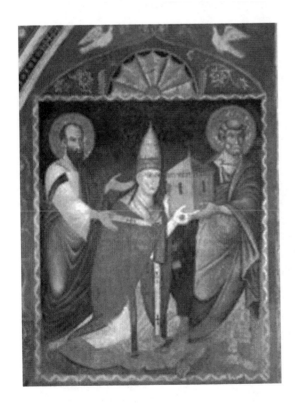

Figure 18: *Pope Nicholas between Saint Peter and Saint Paul Offering the Model of the Sancta Sanctorum Chapel,* **Fresco, Holy Steps, Rome (1279).**

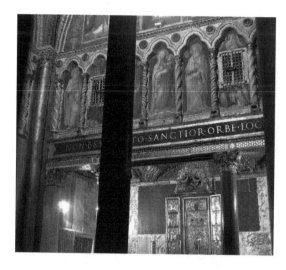

Figure 19: *Two Small side Windows Containing Relics above the Inscription in the Sancta Sanctorum Chapel*, Holy Steps, Rome (1279).

Figure 20: *North Transept Arcaded Gallery*, Basilica of Saint Francis, Assisi (1278).

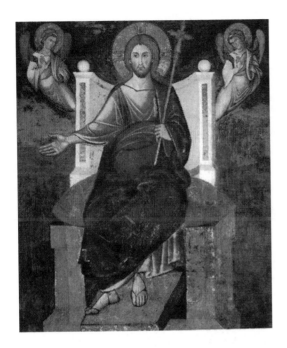

**Figure 21:** *Christ Enthroned and Flanked by two Angels*, fresco, Holy Steps, Rome (1279).

# 3

# THE PATRONAGE OF SIXTUS V AT
# THE HOLY STEPS

❧

## 3.1 From the "Scalae Pilati" to the "Scala Santa"

Before the intervention of Sixtus V, the Holy Steps were known in a medieval manuscript as the Steps of Pilate (Scalae Pilati).[1] The same text describes that the twenty-eight steps were brought from Jerusalem to Rome by Helene, mother of Constantine, in 326 AD and placed in the Lateran palace. In 1521, the Florentine humanist Giovanni Rucellai wrote that Jesus climbed the steps of Pilate on Good Friday and left drops of blood on them, and that during his time the stains were still visible on the second, the eleventh, and the twenty-eighth steps. He added to his description that the faithful who decided to climb the steps on their knees, would get three years of indulgences for each step and a partial remission of sins.[2]

With Sixtus V, after his bull *Cum Singularum Rerum*, issued on May 24, 1590, the Scalae Pilati became the Holy Steps (Scala Santa), as the pope's

---

[1] An anonymous manuscript written in 1375 and currently preserved in the Vatican Library (B.A.V. Vat. Lat. 4265 C. 214) refers to the Holy Steps as *Scalae Pilati* and connects them to the House of Pilate where Jesus was tried.

[2] Giovanni Rucellai and Alessandro Perosa. *Giovanni Rucellai ed il suo Zibaldone*. London: Warburg Institute, University of London, 1960. 33-34.

intention was the integration of the monument into the devotional liturgy and its inclusion in the major urban plan of the new Sistine Rome.[3] The text of the papal decree explained that the Steps used during the Passion of Jesus were repositioned for those who needed to enhance the fervor of their devotion (*ad ardentioris devotionis fervorem inflammandos*); in addition, sinners who went the wrong way could benefit from it as well (*miseros peccatores a recta via aberrantes*). In the intentions of the Renaissance pope, the Steps were a place of meditation, in that the Church exhorted to venerate (*multis et variis cohortationibus*) the mysteries related to the Passion and, on the other hand, through it, it offered a personal moment of contemplation of the sacred images (*sacraeque images nostri oculis devote pia cogitatione procurat*). The document explained also that the Steps were moved from a neglected area of the medieval palace to avoid further damages by time (*temporum injurias*), and that they were placed in the new location regardless of expenses (*nullis parcentes impensis*); in addition, the pope claimed that they were so sacred that no mortal would be allowed to walk or step on them (*pedibus profanis*). The reason of the transportation of the steps to a new, more decent and sacred space was required by the constant flux of pilgrims throughout the centuries to the Sancta Sanctorum, and to instill devotion in a more appropriate place (*aptiore in loco reponeremus*). The Holy Steps of Sixtus V was a work handed over to posterity and a chance to be in contact with the fullest divinity of Christ (*per contactum sacratissimi Corporis Domini nostri Jesu Christi*).[4] The pope's decree highlighted the practical reasons upon which he ordered to be built two more steps on each side of the Holy Steps: to create more room for the increasing flux of pilgrims and to enhance the sole use of the central steps for prayer and not for the ascent or descent of the people (*ne quis per eadem Scalas Sanctas alia*

---

[3] The text of the papal decree is in Gaetano Moroni, *Dizionario di Erudizione Storico-Ecclesiastica da S. Pietro sino ai Nostri Giorni* (Venezia: Tipografia Emiliana, 1840), Vol. 61, 58.

[4] By allowing the faithful to get indulgences when in contact with some of the relics of Christ, Sixtus followed the early medieval tradition of the *reliquiae ex contactu*, which started out with the first pilgrimages to the catacombs and with the construction of the annular crypt by Gregory the Great around the tomb of Saint Peter in the sixth century. Such practice consisted of touching or rubbing the tomb of the martyrs with a piece of cloth, which was considered, after contact, the same as owning a piece of a saint's body. For the literature on the *reliquiae ex contactu* see Vincenzo Fiocchi Nicolai, Fabrizio Bisconti, and Danilo Mazzoleni, *The Christian Catacombs of Rome : History, Decoration, Inscriptions* (Regensburg: Schnell & Steiner, 2009), 23–25.

*quam orandi causa et genibus flexis congrua cum reverentia transeat).* Furthermore, two side steps would grant believers access to two chapels that flanked the medieval Sancta Sanctorum, the chapel of Saint Lawrence and the Chapel of Pope Sylvester I, so that they could stay longer in the monument in prayer. The sidewalls of the Holy Steps are decorated with scenes from the Passion of Jesus, as a complement to the veneration of the sacred image of Christ preserved in the old chapel, but also as a chance to meditate on the sacred mysteries of Christ's life and to redeem the onlooker (*christifideles pia contemplatione meditentur*).

The side chapels would be used to celebrate daily masses by four presbyters, whose salary would be paid with the income deriving from the distribution of the water via the Roman aqueduct restored by the pope (*Aqua Felix*). On the other hand, the money coming from the pilgrims' donations would not be transferred to the papal treasury, but would be used for the preservation and maintenance of the monument itself, the pope stated.

## 3.2  Two Projects of the Holy Steps

To the viewer who today approaches the Lateran, the Holy Steps appear to be a stand-alone monument. The reason of the separation of the Steps from the Basilica of Saint John and from the Lateran palace was not only in the search of a more appropriate place, but also because the pope created a new processional road (modern Via di Porta San Giovanni) that split in two the Lateran complex: Via di Porta San Giovanni, still visible today from the basilica (fig. 22). The street would have been a continuation of that planned to run from the Campidoglio, to the Colosseum and to San Giovanni, whose liturgical significance has been described during the papal ride of the Possesso.[5]

---

[5]  Although of that planned road only the Via Lateranense, which goes from the Colosseum to Saint John was built by Sixtus V (modern Via di San Giovanni in Laterano), Ludwig von Pastor cites an *avviso,* issued in 1587 by the Apostolic Chamber, according to which one of the main priorities of Sixtus was the creation of a straight road terminating at the Holy Steps; for an unknown reason, however, he changed plans and ordered that the road should continue beyond the Holy Steps and terminate at the other processional basilica of Santa Croce in Gerusalemme. See Ludwig von Pastor, *The History of the Popes, from the Close of the Middle Ages.* (London: J. Hodges, 1891), XXII, 428. See appendix, text 8.

Giovan Battista Falda's 1651 engraving (fig. 23) shows what the completed building looked like in the seventeenth century. The loggia, which forms the main facade, has five arches across the front, corresponding to the internal arrangement of the central Holy Steps, and four adjacent lateral stairways. In the middle of the nineteenth century, Pope Pius IX had most of the arches of the loggia filled up with bricks and built the adjacent Passionist convent, which can be seen still today at the bottom of the arcaded aqueduct of Nero.

There is, however, reason to believe that the 1586 plan, destined for a construction to be built in only one year, was subsequently altered and merged into a second plan that was completed in 1589. Sixtus's original plan appears to have focused on simply moving the Holy Steps and the two original lateral stairways from their old location in the Patriarchium to a new location in front of the architecturally isolated Sancta Sanctorum, which was already well advanced in November 1587.[6] The task was performed in one night by the canons of San Giovanni, who made religious processions as they were working. The architect Domenico Fontana, who was in charge of the operations, explained that he had to respect the papal decree that one could only climb the Holy Steps on one's knees; the sanctity of the steps brought him to coordinate the canons while removing the Steps working, on their knees, from the top as they descended. Once the Steps were brought to the new place, the architect wanted to maintain the same order the Steps had in the medieval palace, and asked the canons to set them into place always beginning from the top, contrary to what normally it is required when building a staircase: this technique of laying down the blocks prevented the Steps from being touched by common mortals.[7]

The special status of the staircase brings us to the logical conclusion that the stairway was decorated before the steps were put into place. In fact, it would hardly have been appropriate to have artists and scaffolding all over them. A documented estimate (*stima*) assesses that the decorations

---

[6] Another *avviso* mentioned by Johannes Orbaan describes that in November 1587 the pope was ready to transfer the Steps in front of the Sancta Sanctorum. See Johannes Albertus Franciscus Orbaan *Sixtine Rome.* (New York: Baker and Taylor, 1911).

[7] Fontana in his *Della Transportatione dell' Obelisco* (Second Book, 2) writes that the steps were set up in the new building in only one night, in November 1587. See appendix, text 9.

were completed by January 28, 1588.[8] The frescoes were painted by Cesare Nebbia, who produced the drawings, and by Giovanni Guerra, who was the head of the workshop and hired numerous artists for the project. The mannerist painter and writer Giovanni Baglione lists eleven artists, including himself, involved in the pictorial decoration of the new monument commissioned by Sixtus: Baglione, Paolo Brill, Paolo Guidotti, Andrea Lilio, Paris Nogari, Prospero Orsi, Giovanni Battista Ricci, Giacomo Stella, Cesare Torelli, Antonio Viviani, and Cesare Nebbia.[9] In the walls of the Holy Steps are depicted scenes from the Passion of Christ, whereas in the adjacent lateral stairways episodes from the Old Testament prefigure the Passion; these run chronologically from the top of the stairs to the bottom. Except for a coat of arms of Sixtus V painted in the vault, the far left and right stairways are undecorated. From this piece of evidence, together with an etching (fig. 25) illustrating a book written in 1599 by the presbyter and scholar versed in ecclesiastical disciplines, Pietro Martire Felini,[10] it can be argued that until 1587, the monument had only three staircases, and that between 1588 and 1590, the two outer lateral staircases were added. The reason for adding the extra stairways, Fontana explained, was so that after climbing the central Holy Stairs one could easily come back to them.[11] However, the role of providing an easier path for the faithful to return to the loggia was already fulfilled by the two original lateral stairways. What then convinced Sixtus to add two extra stairways was not so much his concern for pilgrims' accessibility to the monument itself, but rather the idea of creating a separate and more direct access to the new chapels flanking the medieval Sancta Sanctorum, the chapel of Saint Lawrence, and the chapel of Saint Sylvester. Sixtus's upgrade is described in his mentioned bull, *Cum Singularum Rerum,*

---

[8]  Archivio Di Stato Roma (ASR), Giustificazioni della Tesoreria, Busta 16.

[9]  The list is in Giovanni Baglione and Costanza Gradara Pesci. *Le Vite de' Pittori, Scultori et Architetti : dal Pontificato di Gregorio XIII fino a tutto quello d'Urbano VIII (Roma, 1649)* (Bologna: A. Forni, 1975), 53–54.

[10]  See Pietro Martire Felini and Stephan Waetzoldt, *Trattato Nuovo delle Cose Maravigliose dell'Alma Citta di Roma (1610)* (Berlin: Hessling, 1969), 74.

[11]  Fontana, *Della Transportatione dell'Obelisco*, Libro Secondo, 3.

[12] where he decided to enlarge the number of the canons of San Giovanni in Laterano from eight to eleven members. Thus, it seems reasonable to assume that the two rooms and the two extra stairways were added to accommodate the enhanced role of the sanctuary and the increased members of the canons (*collegio sistino*) who attended to the celebration of Mass in the two chapels and were in charge of maintaining the monument with the pilgrim offerings.

The chapel in each room is placed against the wall contiguous with the Sancta Sanctorum. The one on the right is dedicated to Saint Lawrence, preserving the name of the saint to whom the Sancta Sanctorum was originally dedicated. The chapel on the left is dedicated to Pope Saint Sylvester, whose ancient oratory had stood at the top of the Holy Steps in the old Patriarchium Lateranense. The rooms were decorated in their vaults and lunettes during the spring and the summer of 1589, as a document dated July 29, 1589, records.[13] In the final design for the facade's loggia, the low attic seen in figure 25 was discarded in favor of a full two-story structure as seen today, because Fontana's idea was to provide a larger shelter to the visitors during bad weather.[14] The construction of the loggia was terminated in the summer of 1589; an inscription running along the upper part of the facade under the cornice records the completion date as 1589.[15] By the time Fontana and the painters Nebbia and Guerra had received the final payments in the summer 1590,[16] the Scala Santa complex had taken almost five years to complete, and its renovation lasted as long as Sixtus's pontificate. Begun only a month after his election as pope on April 24, 1585, the entire project was finally brought to completion and paid for only a few months before his death on August 27, 1590.

---

[12] *Cum Singularum Rerum* is in Gaetano Moroni. *Dizionario di Erudizione,* op. cit., vol, 61.59.

[13] ASR, Camerale I, Fabbriche, Busta 1528, fol. 86r, "Cesare Nebbia et Giovanni Guerra Pittori deve avere cinque mila cinquecento di moneta per diversi lavori di pitture fatta da loro alle cappellette attaccate al Salvatore."

[14] Domenico Fontana, *Della Transportatione,* op.cit., Libro Secondo, 2.

[15] The inscription reads "SIXTUS V FECIT SANCTIORIQUE LOCO SCALAM SANCTAM POSUIT A MDLXXXIX P IV."

[16] The final payment to Domenico Fontana is recorded in ASR, Camerale I, Fabbriche, Busta 1528, fol. 10.

## 3.3 The Pictorial Cycle of the Holy Steps

In figure 26 is given a detailed map of the pictorial cycle of the entire monument, which comprises a total of five staircases, the medieval Sancta Sanctorum, and the side chapels of Saint Lawrence and Saint Sylvester.

A. ATRIUM
Although the atrium has unpainted walls, its rib vault is decorated with the following frescoes:

> A-E. *Tondi* with the coat of arms of Sixtus V
> B. *Praying Virgin*
> C. *Jesus Savior*
> D. *Saint John the Baptist*
> G. *Spandrels with Angels bearing Instruments of the Passion of Christ*
> H. *Octagons with Paired Angels bearing Instruments of the Passion of Christ.*

B. CENTRAL STAIRCASE (HOLY STEPS) SIDE WALLS
(The order of the frescos follows first the left wall episode and then the right wall one.)
1. Vault spandrels with *Prophets* painted in grisaille
2. Rib Vault with the *Four Evangelists*
   a. *Washing of the Feet (Saint John 13)—Last Supper* (MT 26: 26; MK 14: 22)
   b. *Betrayal of Judas* (MT 26:14–6; MK 14: 10–1)—*Christ predicts to Peter his Betrayal* (LK 22: 1–4)
   c. *Jesus and the Apostles go to the Getsemani* (MT 26: 36)—*Agony in the Garden* (MK 14: 32)
   d. *Christ Points at Judas who is Arriving with the Roman Soldiers* (JN 18: 3–5)—*Christ gives himself to the soldiers* (MK 14: 46)
   e. *Peter Cuts off the Ear of Malchus* (MT 26: 51)—*Arrest of Christ* (MK 14: 46)

f.  *Christ led to the Sanhedrin* (MT 26: 57)—*Flagellation of Christ* (JN 19: 1–3)

g.  *Christ in front of the Priest Hannah* (JN 18: 19–21)—*Denial of Peter* (MK 14: 66–72)

h.  *Jesus in front of Pilate* (MT 26: 69)—*Pilate Questions Jesus and asks Questions the Sanhedrin and the People* (LK 23: 1–3; MT 26: 65)

i.  *Ecce Homo* (JN 19: 5)—*Judas Gives Back the Money* (MT 27: 5)

j.  *Pilate asks the People about the Destiny of Christ* (LK 23: 4–6)— *Herod Orders Christ to be Dressed in a Purple Tunic and Sends him back to Pilate* (MT 27: 27)

k.  *Pilate's Wife Mediates for Christ's Freedom* (MT 27:19)—*Christ Crowned with Thorns* (MK 15: 17)

l.  *Christ and the Three Marys* (LK 23: 27)—*Jesus Deprived of his Clothes* (JN 19: 23)

m.  *Erection of the Cross* (MT 27: 35)—*Two Thieves Crucified* (LK 24: 7)

At the top of the central staircase there are three frescoes:
1.  *Crucifixion* (center) (Mt. 27: 3-5; Mk 15: 24) with the following inscription: VULNERATUS EST PROPTER INIQUITATES NOSTRAS ATTRITUS EST PROPTER SCELERA NOSTRA.
2.  *Resurrection* (left) (MK 15: 24; LK 23: 33)
3.  *Ascension* (right) (MT 28: 1—10)

## C. STAIRCASE LOCATED TO THE LEFT SIDE OF THE HOLY STEPS
(The order of the frescos follows first the left wall episode and then the right wall one.)

It contains episodes of the Old Testament that foretell the Passion and the Resurrection of Christ.

a.  *Creation of Eve* (GN 2: 20-5)—*Tree of Knowledge* (GN 2: 9)

b.  *Original Sin and its Consequences* (GN 3: 6–14)—*Adam and Eve Expelled from Paradise* (GN 3: 23)

c.  *Cain and Abel make Offerings to God* (GN 4: 4–5)—*Cain Kills Abel* (GN 4: 8)

    *d.   Construction of the Ark* (GN 6: 14)—*The Flood* (GN 7: 19)

    *e.   Abraham Sacrifices Isaac* (GN, 22: 9)—*Isaac Blesses Jacob* (GN 27: 26)

    *f.   Dream of Jacob* (GN 28)

    *g.   Jacob's Night Vision at Bet-El* (GN 28: 18)—*Jacob Wrestling with the Angel* (GN 32: 25)

    *h.   Joseph Thrown into a Pit* (GN 37: 23) – *Joseph Sold by his Brothers* (GN 37: 27)

    *i.   The Discovery of Moses* (EX 2: 5–6)—*Moses and the Pharaoh* (EX 7–10)

## D. STAIRCASE LOCATED TO THE RIGHT SIDE OF THE HOLY STEPS

(The order of the frescos follows first the left wall episode and then the right wall one)

    *a.   Institution of the Jewish Passover* (EX 12) —*Passage of the Red Sea* (EX 14: 21)

    *b.   The Lord Disguised as a Column of Fire Stops the Egyptians from Chasing the Jews* (EX 14: 23)—*Moses Orders the Waters of the Red Sea to Close up* (EX 14: 23)

    *c.   Moses with a Cane Makes the Salty Water Sweet* (EX 15: 22)—*Moses Striking the Rock* (EX 17: 5–6)

    *d.   Moses Prays on the Mountain* (EX 17: 3)—*Ark of the Covenant* (EX 25: 10)

    *e.   Carrying of the Menorah* (EX 25: 31)—*Aaron Sacrifices to God* (EX 29: 10–15)

    *f.   Moses and the Brazen Serpent* (NUM 21: 6–9)—*Survey of the Land of Canaan* (NUM 13: 24)

    *g.   Samson Strikes the Lion* (JUD 5: 6)—*Samson Shakes the Columns of the Temple of Dagon* (JUD 16: 25–30)

    *h.   David Slays Goliath* (KGS 17: 50)—*David Plays the Harp* (KGS 16: 23)

    *i.   Jonah Thrown into the Sea* (JA 1: 1–15)—*Jonah Left by the Whale on the Beach* (JA 2: 11)

## G. CHAPEL OF SAINT LAWRENCE
(Access to the chapel is possible once at the top of the far right staircase.)

1–6. *Paired Angels Bearing Symbols of the Passion of Christ and the Eucharistic Wafer*
   A. *Saint Basil*
   B. *Saint Ambrose*
   C. *Saint Augustine*
   D. *Saint Thomas Aquinas*
   E. *Saint Bonaventure*
   F. *Saint Jerome*
   G. *Saint Gregory the Great*
   H. *Saint John Chrysostom*

At the center of the ceiling, three frescoes (a–c) depict angels carrying the coats of arms of Sixtus V and, in the middle (b), the *Trinity*.

Between the ceiling and the walls the following inscription runs all around the chapel (Paul, Letter to the Corinthians 1.2.2), "ITEM PRAEDICAMUS CHRISTUM CRUCIFIXUM IVDAIES QUIDEM SCANDALUM GENTIBUS AUTEM STULTITIAM IPSIS AUTEM VOCATIS IVDAEIS ATQUE GRAECIS CHRISTUM DEI VIRTUTEM ET DEI SAPIENTIAM." The translation: "While the Jews look for a sign and the Greeks search for wisdom, we instead announce Christ on the Cross, which is a scandal for the Jews and stupidity for the Gentiles; however, for those who will be called Christ, it is expression of the power and the wisdom of God."

## H. CHAPEL OF SAINT LAWRENCE
(Access to the chapel is possible once at the top of the left staircase)
   a. In the middle of the ceiling, the fresco with the *Coat of Arms of Sixtus V*
   b. *Two Landscapes with Angels Carrying Symbols of the Passion of Christ*
   A. *Christ Wearing a Royal Crown*
   B. *Christ Wearing a Crown of Thorns*
   C. *Ecce Homo*

The selection of Old and New Testament scenes in the pictorial cycle of the Holy Steps has biblical references and dates back to the *Dream of Jacob*

(Genesis 28:18). In the Bible, Jacob lies down for the night at Mount Moriah, the future home of the Temple in Jerusalem. As he was dreaming, he had a vision of a ladder, or stairway, between heaven and earth. God's angels were on it, ascending and descending. Jacob saw God standing above the ladder. God repeated the promise of support he had made to Abraham and Isaac. He told Jacob his offspring would be many, blessing all the families of the earth. When Jacob awoke, he believed that God was present in that place. He took the stone he had been using to rest his head, poured oil on it, and consecrated it to God. In the biblical context, the ladder symbolizes the attempt of God to reach out to man. In this instance, it was God who provided the means necessary to link himself to man, as opposed to the men of Babel in Genesis 11, who tried to reach heaven with their own actions, aside from the help of God.

In Christian theology, on the other hand, the ladder signifies the spiritual elevation and purification of the soul that, once arrived at the top of the steps, will be able to contemplate God.[17] In the third century, Origen explains that there are two ladders in the life of a Christian, the ascetic ladder that the soul climbs on the earth, resulting in an increase in virtue, and the soul's travel after death, climbing up the heavens toward the light of God.[18]

In addition, at the time of Sixtus, the text *Climax Paradisi*, written for the Greek Orthodox liturgy by John Climacus in 600 AD but translated into Latin in Venice only in 1531 by Ambrogio the Camaldolese, was very popular among the religious orders, such as the Franciscan.[19] The ascetical treatise is addressed to the cenobites and discusses the means by which religious perfection may be attained. The text is divided into thirty parts or "steps," in memory of the thirty years of the life of Christ. It presents a picture of all the virtues and contains many parables and historical facts, drawn principally

---

[17] Ireneaus, Adversus Haereses, III, 24, 1 in Irenaeus, Dominic J. Unger, John J. Dillon, M. C. Steenberg, and Michael Slusser, *Against the Heresies* (New York, N.Y.: Paulist Press; Newman Press, 1992), 77–78.

[18] Origen, Homily n. 27 about Numbers 33:1–2. See Thomas P. Scheck and Christopher A. Hall. *Origen, Homilies on Numbers.* (Downers Grove, IL: IVP Academic, 2009), 97–102.

[19] Joannes Climax, *The Ladder of Divine Ascent* (New York: Paulist Press, 1982).

from the monastic life, and discusses the practical application of the precepts, in order to bring the monk from a world of vice to a new life spent in God's contemplation and love.

## 3.4 The Pictorial Cycle as Itinerary Indicator

For Sixtus, the transportation of the Steps from the medieval residence into the new architectural building envisioned by Domenico Fontana was not only a matter of creating a place for penance, but also the possibility of endowing his *Roma Felix* with a sanctuary open to anyone looking for meditation on the mysteries of the Passion of Christ. In this regard, the cycle of frescoes he had commissioned acts as "Itinerary Indicator."[20] In fact, the paintings of the central staircase cannot be fully understood if they are not compared to the Old Testament cycle that adorns the side steps, used during the descent from the Holy Steps.

The atrium functions as an introduction to the sanctuary; the ceiling, decorated with angels carrying the symbols of the Passion of Christ, introduces the visitor to the main topic explored in the monument. The atrium is connected to the central steps by means of a quadripartite rib vault that depicts the Four Evangelists and stands as indicator of the four Gospels where the accounts of the Passion of Christ originate. The first two frescoes, located at the beginning of the main staircase, narrate the *Washing of the Feet* and the *Last Supper*: the two episodes recall the religious practices performed by the popes in the medieval period in their residence during Maundy Thursday, among which was the washing of the feet of deacons attending the Mass. The main staircase is decorated with twenty-eight episodes of the Passion of Christ to be read from right to left. It is also interesting to point out that all the frescoes have a low vantage point, justified by the fact that onlookers have to look at the paintings from a kneeling position. In addition, the cycle of the main staircase is located above

---

[20] The expression is used in Alessandro Zuccari, *I Pittori di Sisto V.* (Roma: Palombi, 1992), 107.

a marble base to protect it from the crowd of pilgrims and to enhance its legibility; in fact, the stories are located at the right distance between the wall and the human eye and do not require the head of the viewer to be turned toward them, as it is enough to roll the eyes to appreciate them. The perspective is reduced to a minimum in order to avoid the distraction of the viewer who, once at the top of the steps, is able to admire the final events of the Passion of Christ culminating in his *Death, Resurrection,* and *Ascension.*

The staircases next to the Holy Steps contain nineteen stories of the Old Testament; they begin chronologically at the top with the *Creation of Eve* and their ceilings can be read only in descending order, as they were meant to help people evacuate the main staircase and symbolize the fall from grace. The concluding scene at the bottom of the left side staircase is *Jonah and the Whale,* and the one at the bottom of the right side staircase is *Moses with Pharaoh.*

There is also the possibility to read the stories horizontally and compare them with other stories located on the same level in the other steps. For example, the stories at the top of the three staircases are linked to one another by the different types of alliances mankind has made with God: the *Creation of Eve* and the *Institution of Passover* recall the first alliances narrated in the Old Testament; on the other hand, the story at the top of the Holy Steps, the *Crucifixion,* reveals the path toward the new alliance with God and acts as the perpetual effort of humanity to harmonize its relationship with God. Similarly, the *Sacrifice of Isaac,* the *Brazen Serpent,* and the *Ark of Noah,* champion the need of faith in order to be a good Christian and attain salvation.

There is reason to believe that the pictorial cycle commissioned by Sixtus was directed to catch the attention of two types of audiences. The Passion of Christ shown in the main staircase aimed at reenacting the liturgical ceremonies performed during Maundy Thursday and Good Friday; it conforms to the *sermo humilis,* a humble style of preaching that, both in form and content, was based on historical episodes and concrete experience. As Franciscan friar first and then pope, Sixtus felt compelled to comply with the words spoken

by the Crucifix of Saint Damien to Saint Francis: "Go and repair my house"[21] at the moment of planning to move the steps into a brand-new sanctuary dedicated to the Holy Week. On the other hand, Sixtus was a capuchin, too, and like the other minor friars, he was used to the *sermo thematicus* that expounded principles and served as a stage for the teachings of the Christian doctrine. In this type of sermon, an event of the Bible painted by an artist did not follow rigorously the events and the characters mentioned in that text but acted as a container for other anachronistic stories told within the same text. Thus, each Old Testament story required a more educated audience and more time to be read fully and understood, since it did not follow the preceding or the ensuing story and was a microcosm itself. Moreover, preaching by themes is canonical in the Gospels, whose best examples are the parables of Christ, which put the known next to the unknown, so that spiritual lessons can be learned from nature or human circumstances. If the *sermo humilis* revealed to the curious, the *sermo thematicus* was more directed toward the truth seeker and taught doctrinal principles embedded in one or more topics.

The ultimate basis for understanding the simultaneous presence of Old and New Testament scenes within the same building is the medieval view of the Bible in which theologians classified biblical imagery in its literal or historical sense and in the spiritual sense, which comprises the allegorical, the tropological, and the anagogical one as well. These different aspects of the sacred were understood in the Renaissance as complementary and harmonious facets of one divinely ordained truth. Franciscans, who had made devotion to Christ the cornerstone of their spirituality, encouraged serious meditation on the Passion and death of Christ.[22]

---

[21] See Thomas of Celano, biographer of Saint Francis in Tommaso da Celano. *San Francesco : Vita Prima*. Torriana (FO): Orsa Maggiore, 1993. 44-46.

[22] The Franciscan theologian Bonaventure of Bagnoregio wrote in 1255 a fundamental liturgical text on the events of the Passion that he correlated to the canonical hours (*Officium de Passione Domini*). See Bonaventura da Bagnoregio, *Seraphici Doctoris S. Bonaventurae Decem Opuscula ad Theologiam Mysticam Spectantia* (Ad Claras Aquas (Quaracchi): Collegium, 1900).

# LIST OF IMAGES CHAPTER THREE

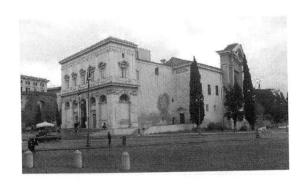

Figure 22: Via di Porta San Giovanni, built by Sixtus V to transform the Holy Steps as a stand-alone monument (1590).

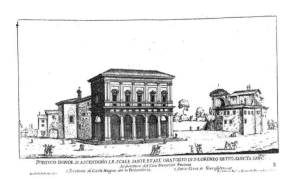

Figure 23: *Scala Santa*, engraving of Giovambattista Falda from *Il Nuovo Teatro delle Fabbriche, et Edificii, in Prospettiva di Roma Moderna*, 4 vols. (Rome 1665), Libro III, tav. 8.

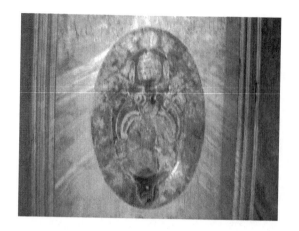

Figure 24: *Coats of Arms of Sixtus V,* ceiling of the far left staircase, fresco, Holy Steps, Rome (1588).

Figure 25: *Facade of the Holy Steps with Three Arches Leading to Three Stairways,* etching illustrating Pietro Martire Felini's *Trattato Nuovo delle Cose Meravigliose dell'Alma Città di Roma,* etching, Rome, 1610, 4.

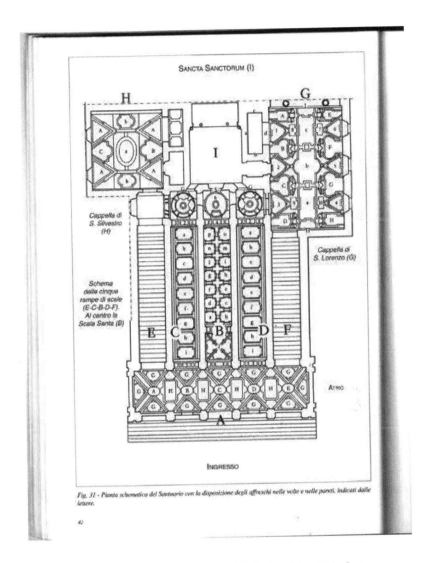

Figure 26: Map of the Pictorial Cycle of the Holy Steps

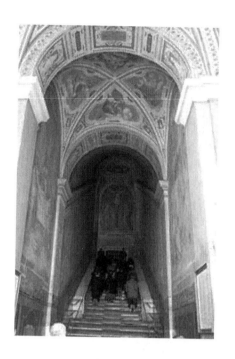

Figure 27: Quadripartite Rib Vault (upper foreground) depicting the *Four Evangelists* and Linking the Atrium to the Main Staircase, Fresco, Holy Steps, Rome (1588).

# 4

# THE PAINTERS OF THE HOLY STEPS

❧❧

## 4.1 The Iconography of the Scala Santa

As discussed above, the pictorial cycle of the Holy Steps was frescoed before the Steps were set in place, since nobody was allowed to walk on them, as they had originally belonged to the place where Christ met the Roman governor Pilate. The Steps were moved from the old medieval palace in October 1588; in May 1587, the fresco decoration of the main staircase was completed, and in January 1589, the entire monument's interiors were painted as well, as recorded in the last payment on July 29, 1589.[1] The pope himself did not select the stories to be painted in the building but asked the Cardinal Silvio Antoniano to provide the painters with the episodes of the Old and New Testaments.[2] Antoniano envisioned the cycle of the Passion of Jesus as an illustrative comple-

---

[1] Archivio Di Stato Roma (ASR), Giustificazioni della Tesoreria, Busta 18.

[2] In 1610, Giuseppe Castiglione, biographer of the cardinal Antoniano, wrote that the Cardinal was asked by Sixtus to provide the inscriptions at the base of the Sixtine obelisks and the iconografic program of the Sistine Chapel in Santa Maria Maggiore. See Almamaria Tantillo Mignosi. *Villa e Paese : Dimore Nobili del Tuscolo e di Marino : Mostra Documentaria: Roma, Museo di Palazzo Venezia, Marzo-Maggio 1980* (Roma: De Luca, 1980).

ment to the *Andachtsbild* of the medieval *Acheropoieton* still preserved in the Sancta Sanctorum. He was an expert educator who previously was a disciple of St. Philip Neri and teacher to St. Charles Borromeo. He wrote in 1586 a treatise on the Christian education of youth (*Dell'Educazione Cristiana e Politica de' Figliuoli*),[3] in which he said that the activity of the teacher should lead the Christian to perform active roles in the three main societies: the family, the civil society, and the Church. The more closely the temporal power of a nation aligned itself with the spiritual, and the more it fostered and promoted the latter, the more it contributed to the conservation of the commonwealth. It was the aim of the ecclesiastical authority, by the use of spiritual means, to make a good Christian in accordance with its own particular end and object, which was mainly salvation; and in doing this, the Church helped at the same time to make good citizens and prepared them to meet their obligations as members of a civil society. This followed of necessity, because in the City of God, a good citizen and an upright man were absolutely one and the same thing. Therefore, those who separated things so closely united were in error, and those who thought that they could produce good citizens by ways and methods other than those used to make good Christians should consider the Christian education, since it was impossible to produce true temporal peace and tranquility by things contrasting the peace of Celestial Jerusalem.[4]

In the context of the Holy Steps, located in Rome, the New Jerusalem, the selection of episodes employed by Antoniano purposely emphasized the intentional and didactical reiteration of the events preceding the arrest of Christ (namely four, *Christ and the Apostles go to Gethsemane, Christ Foretells Peter's Betrayal, Agony in the Garden, Christ Talks to an Angel*), because the aim of the cardinal was the analytical rendering of the Gospel into images that could illustrate what Christ had to go through in order to create the New Alliance under his name.

The painters who worked at the Steps, although instructed by Antoniano on the subject to represent in the frescoes, did not draw the stories from

---

[3] See Vittorio Frajese. *Il Popolo Fanciullo: Silvio Antoniano e il Sistema Disciplinare della Controriforma* (Milano: Angeli, 1987), 23–46.

[4] *Il Popolo Fanciullo*, op. cit., 49–50.

scratch but used prototypes already circulating in the illustrated Bibles of that period. The scene of *Cain and Abel,* for example, has similarities with an engraving illustrating the same topic by Antoine Lafrery, a French publisher active in Rome since 1543, whose major work was the *Speculum Romanae Magnificentiae,* the text that described ancient Roman buildings, anatomical studies drawn from the papal collection in the Belvedere at the Vatican, and mythological scenes intertwined with biblical episodes as well. For the scene of the *Original Sin,* on the other hand, with the image of the *Death* that precedes *Adam and Eve,* it seems that the workshop of Cesare Nebbia and Giovanni Guerra looked at the engraving created in 1540 by the German artist Hans Lutzelburger, based on a drawing of Hans Holbein (fig. 28). Among the other illustrated books, the artists may have also referenced the *Thesaurus Sacrarum Historiarum,* a collection of Flemish engravings brought together for an audience of essentially artists and collectors, published in Antwerp in 1585 by Gerard de Jode and exhibited in the British Museum in London. The *Thesaurus* came into play when the artists needed inspiration for the creation of landscapes that had to convey the accurate representation of the forces of nature occurring at the moment of the main events represented. Even the *Dream of Jacob* (fig. 29) reveals a striking influence from the Flemish landscape painting. Jacob is shown sleeping in the pose usually employed for the *Sleeping Ariadne* and is slightly off-centered. A centrally positioned tree, at the bottom of which he is depicted sleeping, characterizes the naturalistic landscape that populates the scene. The tree splits the scene in two chronologically distinct events. On the left side, the shepherd crosses the Jabbok River, a tributary of the Jordan; on the right side, the ladder climbed by the angels creates a diagonal line that opens up a blurred view on the city of Bethel, built by him at the end of the dream. The accuracy in the rendering of the tree foliage in the episode reveals the possibility of distinguishing three types of trees: the palm trees on the left side evoke a Nilotic landscape, the oak tree hovering over Jacob symbolizes strength, and the elm tree on the right conveys the idea of faithfulness and dignity of the Jewish forefather.

On the other hand, some scenes of the Passion cycle refer to contemporary works painted by the same artists in other buildings of Sistine Rome.

For example, a few years before working at the Holy Steps, Cesare Nebbia had been frescoing in 1576 the walls of the Oratory of Gonfalone with one of the most relevant cycles of the Counter-Reformation art under the patronage of the Cardinal Alessandro Farnese.[5] His *Crowning of Thorns* (fig. 30) has been re-proposed at the Steps as a crowded scene, where several unrelated figures look at the suffering Jesus in a crammed vertical space created by Nebbia through the subdivision of the picture plane into many painted steps. Although the man holding on to the column in the upper left corner is a citation from the *Expulsion of Heliodorus* by Raphael, the fresco confirms its departure from the Renaissance rules of a balanced composition, since it shows groups of people talking to each other and not involved in the main scene at all; moreover, their rendering via a *figura serpentinata* enhances their theatricality and fits the purpose of the counter-reformed art that aimed to be easily understood by common people when showing saints in blatant gestures.[6] Similarly, the episode of *Jesus Meeting the Three Marys* (fig. 31), frescoed by Nebbia in 1575 for the Borghese Chapel of Santa Maria in Santa Trinita dei Monti,[7] was used as model for the same episode in the Holy Steps, granting less expert artists a fast learning curve of their masters' works, when they were under pressure dictated by the papal commissions. What Sixtus needed

---

[5] Pope Urban IV appointed the members of the Oratory of Gonfalone in 1264; they managed hospitals and charitable institutions in Rome. One of their main activities, however, was the dowry endowment of the poor ladies and the reenactment of the Passion of Jesus at the Colosseum in Rome. The fresco cycle of the oratory was commissioned as a memento of the public activity of this brotherhood during the Counter-Reformation. This also explains why still today, on Good Friday, the Pope celebrates the Stations of the Cross at the Colosseum. On the role of the Oratory of Gonfalone during the Counter-Reformation see Barbara Leslie Wollesen-Wisch, "The Arciconfraternita del Gonfalone and its Oratory in Rome : Art and Counter-Reformation Spiritual Values," Thesis (PhD), University of California, Berkeley, 1987.

[6] On the relationships between Cesare Nebbia and the other artists working at the Oratorio del Gonfalone see the main study *Oltre Raffaello—Aspetti della Cultura Figurativa del Cinquecento Romano*. (Roma: Multigrafica Editrice, 1984), 161–164.

[7] Even before the Oratory of Gonfalone, Nebbia obtained a private commission and was hired by the father of the future Pope Paul V Borghese, Giambattista, to decorate the family chapel dedicated to the Invention of the Cross at the top of the Spanish Steps. This chapel predates the Pauline Chapel built by Paul V in the basilica of Santa Maria Maggiore.

in the artists he hired for his projects was a relatively low interest in the quality of the product and a fast execution of the work at a cheaper rate.

## 4.2 Preliminary Considerations on the Workshop's Organization

The frescoes of the Holy Steps can be subdivided into three groups: the ones painted directly by Cesare Nebbia, the drawings created by him but painted by his apprentices, and the landscape scenes painted by the Flemish artist Paul Bril. In addition, as other works conducted under Sixtus in Rome show,[8] the practice of painting large frescoes in the shortest amount of time possible implied three categories of people: the patron, who in this case was the pope acting through the Cardinal Antoniano; the head of the workshop, who was able to translate into a figurative episode the idea of the patron; and the workshop of artists, who had the final job of decorating walls and ceilings under the instructions of their masters. Cesare Nebbia and Giovanni Guerra reported to the main superintendent of the whole project, the architect Domenico Fontana.

Giovanni Baglione, painter and writer who participated in the project, wrote that the painters, besides being very capable artists, were also good managers of their workshop, in that they had to coordinate around one hundred artists and supply prime materials such as colors and gold. Baglione also noted that the two artists used an assistant who controlled the productivity of each apprentice and the quantity of colors previously received: the work was judged not on quality but only if the quantity of color received was properly transferred onto the frescoed wall.[9]

---

[8] The essay *L'Organizzazione dei Cantieri Pittorici Sistini* by Mario Bevilacqua in Maria Luisa Madonna, *La Roma di Sisto V. Le Arti e la Cultura* (Roma: De Luca, 1993), 38–43, discusses how Cesare Nebbia and Giovanni Guerra rationalized their activity in Rome with a very efficient workshop that was able to handle all the requests made by Pope Sixtus.

[9] Giovanni Baglione, *Le vite de' Pittori, Scultori et Architetti*, 69–72.

In order to understand the large amount of money Nebbia and Guerra had earned during the pontificate of Sixtus, the archival records of the Academy of Saint Luke for the years 1588–1599 mention the annual fee paid jointly by the two in the amount of 73,77 *scudi*, out of 103,77 *scudi* paid in total by twenty-one painters themselves.[10] In total, the workshop of Guerra and Nebbia earned, between 1587 and 1590, the amount of about 30,000 *scudi*.[11] There is no extant documentation regarding the company founded by the two artists, although the Renaissance workshops in Rome were constituted with private agreements or with statutory rules approved by a notary.[12] Presumably, the company of Nebbia and Guerra had accountants and bookkeepers in charge of updating entries related to income, expenses, the amount of colors purchased, and the hierarchical relationship among the artists working in the workshop. The only available documentation is the one related to the *stime dei lavori*, which were estimates about the costs and the phases of the work to be done. According to the practice of that time, the estimate was submitted for approval to two consultants—one hired by the patron and the other by the artist—who normally deducted 10 percent from the whole cost of the work. After the death of Sixtus, the company of Nebbia and Guerra was terminated. The two painters suffered the anger and envy of the successors of Sixtus and were reported for having earned too much money on the color supplies. They were, however, able to avoid standing trial because they had powerful patrons such as Cardinal Montalto, nephew of the deceased pope; before retiring, they participated in the fresco decoration of the transept of Saint John in Lateran in the year 1600 under the direction of the young Cavalier d'Arpino and the patronage of Pope Clement VIII.[13]

---

[10] In ASR, Camerale I, Fabbriche, Reg. 1527, fasc. 40.

[11] *L'Organizzazione dei Cantieri Pittorici Sistini*, 43.

[12] The archives of the Capitoline notary record the foundation of a company of painters created in 1586 by Gaspare Bianchi and Cesare Nebbia. The foundation act is discussed in Gian Ludovico Masetti Zannini, *Pittori della Seconda Metà del Cinquecento in Roma* (Roma: De Luca, 1974), 102–104.

[13] On the artistic production in Rome between Sixtus V and Clement VIII see Stefania Macioce. *Undique Splendent : Aspetti della Pittura Sacra nella Roma di Clemente VIII Aldobrandini (1592-1605)* (Roma: De Luca edizioni d'arte, 1990), 46–52.

## 4.3 Giovanni Guerra: The Artist as Inventor

In his *Vite*,[14] Giovanni Baglione explained that the main activity of Giovanni Guerra was to create drawings to be engraved in a durable material in order to let the "princes of the world understand and learn his stories."[15] The words of Baglione implied an intentionality that went beyond the moment of the artistic creation and attempted to engage the recipients of his output. His interesting passage referred to the role of the artist as *inventor*, at the end of the Cinquecento, who already acknowledged the didactical role of the image. Baglione went even further when he discussed the relationship of the artists within the Holy Steps's workshop. "Giovanni Guerra created the stories and Cesare Nebbia translated them into drawings."[16] In addition, the author explained[17] how Guerra constantly expressed his opinions about other works being conducted under Sixtus, a practice that made him not only an inventor but also an art consultant who was split between thought and action.

The activity of Guerra as engraver is better known through the illustrations to the *Iconologia* of Cesare Ripa, published in 1603.[18] Francesco Forciroli, the artist's first biographer, explained that Guerra was rather well regarded for his "invention, drawing and manner of ornamentation...yet was not much appreciated as a colorist."[19] A small book of drawings illustrating the story of Judith in the Avery Library at Columbia University in New York reveals his intellectual aspirations and his status as a *pittore erudito*. One of the eight hundred drawings by Guerra, *Saint Paul Preaching at Ephesus* at the Uffizi (fig. 32), attempts to capture the moment in which, according to the Acts of the Apostles, Saint Paul, seated on a chair positioned on a higher pedestal, tries

---

[14] Giovanni Baglione, *Le vite de' Pittori, Scultori et Architetti*, 49–52.

[15] Giovanni Baglione, *Le vite de' Pittori, Scultori et Architetti*, 50.

[16] Giovanni Baglione, *Le vite de' Pittori, Scultori et Architetti*, 50. See text 10.

[17] Giovanni Baglione, *Le vite de' Pittori, Scultori et Architetti*, 51.

[18] For the relationships between Cesare Ripa and Guerra, see the enlightening article by Stefano Pierguidi, "Giovanni Guerra and the Illustrations to Ripa's Iconologia." *Journal of the Warburg and Courtauld Institutes* 61 (January 1, 1998): 158–175.

[19] The biography of Forciroli is included in Sonia Cavicchioli and Giorgia Mancini. *Vite dei Modenesi illustri*. (Modena: Aedes Muratoriana, 2007), 216–231.

to convince the Ephesians of the necessity of being baptized rather than honoring the pagan cult of Artemis-Diana. The scene shows how the people of Ephesus are listening carefully to the apostle of the gentiles who addresses the Ephesians with a blessing gesture that recalls the ancient Roman *adlocutio*. Needless to say, the sacrament of christening was the response of the Church to the Lutheran attacks, regarding which Eucharist and christening ceremonies do not require priestly status to be performed, although ministers of the church are necessary and useful to directing and guiding the sacred functions. Moreover, Guerra's personally frescoed *Expulsion of Adam and Eve* in the Holy Steps (fig. 33) can also be interpreted within a moralizing context of God/Virtue punishing Vice/Adam-Eve, since a common *topos* of Florentine Mannerism was the representation of psychomachies, such as the *Allegory of Justice* painted for Paul III Farnese by Perin del Vaga in 1541 in the Paoline Hall in Castel Sant' Angelo, in which vices are subjugated by justice, and the Salone dei Cento Giorni frescoed by Vasari in 1544 in the Palazzo della Cancelleria. Both the drawing depicting Saint Paul and the fresco with the *Expulsion* relate to the Renaissance dialectic use of the word expressed through the images, or *ekphrasis*, whose scope is not simply to provide astute details of a story or an object, but to share the emotional experience and content with the believers who had never encountered or read about such sacred stories. Through the evocation of biblical scenes, the role of the painter was to inspire responses beyond the pictorial surface; from these descriptions the Renaissance painter was invited to reconstruct images from the past and move the passions of the viewer.[20] Thus, Guerra's *invenzioni* were a combination of mannered naturalism, expressed through motivated gestures, along with design conventions inherited from his background as an engraver. These factors determined his popularity in Rome, first as an intellectual set apart from the day-to-day work and the pressure of the Sistine commissions, and then as an innovative creator, whose works well fit the intentions of the patron to educate the rich and the poor through the illustration of stories with moral content.

---

[20] The use of *ekphrasis* as appropriation of the classical literary model for a discussion of the art of painting that serves to ennoble the subject itself is in Alberti's De Pictura. See David Rosand. "Ekphrasis and the Generation of Images." *Arion* 1, no. 1. Third Series (January 1, 1990): 61–105.

## 4.4  The New Idealism of Cesare Nebbia

Nebbia partnered with Giovanni Guerra during the decoration of the Scala Santa. Before working under Sixtus V, he participated in the fresco decoration of the cathedral of Orvieto with his master, Girolamo Muziano; he also played a major role in the mosaic decoration of Gregorian Chapel in St Peter's Basilica and in the decorative cycle of the Gallery of the Geographical Maps in the Vatican during the administration of Gregory XIII (1572–1585). His *Christ the Redeemer* (fig. 34), painted for the Church of Santa Susanna, shares with *Christ Meeting the Three Marys* of the Holy Steps Jesus's awareness of being left alone to his destiny. Nebbia's favorite rendering of the pensive Christ posited the mannerist artist between the end of the structured composition popular in the Renaissance and the beginning of a new form of idealism in the religious art of Rome. Nebbia gave his dense brushstrokes a decorative value, where the narrative content derived from an emphatic realism of the figures acting within the depicted events.

Neither of his Christs conveys violence, according to the events in which they are participating but rather anticipate the coming events with a sad and inanimate expression. Cesare Nebbia expunged from his Christs any emotion and devitalized the action in order to make his figures self-contained and almost insensible to the patterns of actions. His narrative was not limited to the illustration of events but asked the viewer to project his considerations on the meanings of the events themselves. Whereas Guerra's *Expulsion* has a holistic approach, in that the artist tried to recreate the scene using atmospheric effects and color *cangiantism* in the deep folds of Adam and Eve's clothes, Nebbia opted for graphic precision and markedly emphasized the contours of each figure and form.

Similarly, on the back wall of the corridor at the top of the main staircase is the fresco of *Moses and the Brazen Serpent* (fig. 35), a derivation of Michelangelo's same subject on the Sistine ceiling. It was painted by Ferrau' Fenzoni in 1587 based on a drawing [21] of Cesare Nebbia that is now in a private collection

---

[21]  According to Rhoda Eitel-Porter, Cesare Nebbia created eighteen drawings for the pictorial cycle of the Holy Steps. Her catalogue raisonne' on Nebbia discusses the entire production of the Umbrian artist. See Rhoda Eitel-Porter. *Der Zeichner und Maler Cesare Nebbia, 1536-1614.* (München: Hirmer, 2009).

(fig. 36). The arched top of Nebbia's drawing anticipates the shape of the fresco, with which it shares a number of details. Moses stands at the left, pointing toward the brazen serpent with a stick and looking down at a kneeling woman who, supported by a man behind her, leans forward, raises her arms in imploring gesture. The fresco and the drawing show a similar background: for instance, the figure near the center who fends off a snake circling up his extended right arm is common in both. A comparison of the two works, however, the fresco of Fenzoni and the drawing of Nebbia, reveals the different artistic temperaments of the two artists. Fenzoni followed Nebbia's overall design, rejecting Nebbia's idealism and equilibrium and moved toward a more dramatic composition. Working along diagonals, Fenzoni balanced the group of the hopeful at upper left against those at lower right, for whom there is no hope of salvation. Nebbia, by contrast, obviously preferred to gather the crowd more or less in a circle around the T-shaped cross. If Fenzoni created contorted figures in the foreground, with their arms unnaturally twisted behind their backs, Nebbia avoided the overlapping of people and populated his scenes with gracious contours.[22] Both painters were redolent of the artificiality of the Roman Mannerism, which fostered multiple points of view, and where there was no hierarchy between primary and secondary events represented. Accumulation of scenes characterized the artists working for Sixtus, in opposition to the synthetic representations created by the Renaissance masters such as Raphael.

A drawing by Nebbia preserved in the Cabinet des Dessins at the Louvre (fig. 36) reveals the modus operandi of the workshop of the Holy Steps. The sketch shows three scenes happening at the same time: the *Kiss of Judas*, the *Arrest of Christ*, and *Peter Cuts off the Ear of Malchus*. The three episodes of the Passion of Christ were split once they had to be converted into frescoes: Nebbia painted only the *Kiss of Judas*, whereas Giovanni Baglione gathered the other two frescoes in only one picture, the *Arrest of Christ*, located in the middle of the main staircase. The purpose of such a *modello* was twofold: it facilitated the understanding and

---

[22] On the relationships among the artists employed simultaneously in several pictorial enterprises by Sixtus V, see the article of Rhoda Eitel-Porter. "Artistic Co-Operation in Late Sixteenth-Century Rome: The Sistine Chapel in S. Maria Maggiore and the Scala Santa." *The Burlington Magazine* 139, no. 1132 (July 1, 1997): 452–462.

the approval of the scenes by the patron, and at the same time helped the painter of the workshop to have a better grasp of the narrated cycle. On the other hand, three episodes in one allowed the draftsman to move quickly to the next drawing.

## 4.5  The Landscapes of Paul Bril at the Holy Steps

The Flemish brothers Paul and Matjis Bril arrived in Rome in the 1570s and began running a successful workshop dedicated to the representation of landscapes on small easel paintings. Before working for Sixtus, Paul was hired by Gregory XIII to decorate the Torre dei Venti in the Vatican, where he alternated a philological rendering of the Roman ruins with a freer rendition of the landscape of the *Campagna Romana,* in which a bizarre nature contrasts with the marvels of what was Rome (fig. 37). The landscapes created by Bril were meant to celebrate the period of the ruling pontiff: the symbols of the glorious past of Rome are linked to charity scenes, transforming an urban landscape into a Christian territory where good deeds educate the viewer on the virtues of the perfect Christian. On the other hand, nature was seen in the post-Tridentine period not only as functional to religious meditation, but also as an expression of the love of God for mankind, and the painter's role was to please the eyes of the viewer by displaying the things that were already beautifully created by God.[23]

Giovanni Baglione attributed to Paul Bril two frescoes with the episode of Jonah at the Holy Steps.[24] In *Jonah Thrown into the Sea* (fig. 38), the artist used his eclecticism by juxtaposing the biblical scene with the representation, on the top right, of the Tomb of Cecilia Metella located in the Appian Way. The handling of light in Bril's representation of the storm occurring while the whale is swallowing Jonah proved to be Bril's main characteristic when he needed to create spatial progression. The spatial construct created by the atmospheric effect draws the eye diagonally from the background to the foreground. Starting from the left side, the sky is cleared up by the sun, then in

---

[23]  In his *Discorso Intorno alle Immagini Sacre e Profane,* (op. cit., 69–70), Gabriele Paleotti considered positively painting as revelatory of the magnificence of God toward Nature.

[24]  See appendix text 11

the middle threatening gray clouds hover over the boat, finally on the right divine sunrays pierce the clouds and illuminate the shore foreshadowing the end of the storm and the proximity to safer land. *Jonah Disgorged by the Whale* (fig. 39) was, on the other hand, his attempt to monumentalize the faith and the heroism of the prophet who had waited three days in the whale's body until the end of the storm. In this second fresco, it is possible to realize that Paul Bril followed the canons of the Italian painters of *istorie*, as the action depicts the moment in which the prophet is catapulted from the fish to the shore. He painted a storm at sea with a lowering sky, foam-capped waves and a broken ship's mast. In the distance—behind the still airborne Jonah—Paul Bril painted a splendid city with towers, an obelisk, and a round temple, set against a mountainous background. Moreover, the figure is quite different from the small Jonah above it in the vault, which can indeed be attributed to Bril. In that scene, Jonah is portrayed as an elderly man with a gray beard, which contrasts with the clean-shaven young man on the wall. Examined under floodlight, the lines scored into the wet plaster reveal that the figure of this second fresco was painted in a different *giornata,* and therefore not at the same time as the landscape.[25]

Similarly, Bril painted the landscape in *Jacob's Dream* in the vault. The tree under which Jacob sleeps divides the picture space in two parts, which allowed Bril to paint a high landscape on the left and a view into the distance on the right, where a solitary wanderer, who is not mentioned in the biblical account, heads in the direction of a tower on a hilltop. In addition, after having previously participated in the decoration of the lunettes in the ceiling of the chapel commissioned by Sixtus in Santa Maria Maggiore, Paul's last work at the Steps was the depiction of four landscape scenes for the lunettes in the annexed chapel of Saint Lawrence. The four scenes, *Rocky Landscape with Two Artists, Landscape with a Horseman, Servant and Two Travellers, Landscape with a Beggar and a Merchant,* and *Landscape with a Man and a Mule,* incorporate a panoramic view, a high horizon, and a great variation in different planes.

---

[25] The observation about the contrast between figures and landscapes in the activity of Paul Bril at the Holy Steps is discussed in Carla Hendriks, *Northern Landscapes on Roman Walls : the Frescoes of Matthijs and Paul Bril.* (Florence, Italy: Centro Di, 2003), 52–54.

There is human activity in all of them: horsemen and hunters make their way through the countryside with a prancing dog at their side, a merchant and his mule trudge into the hills, a man carrying a basket of fruit passes a beggar.

All the vistas painted by Brill at the Steps not only show the destructive power of nature, but also the principle of plenitude that pertains only to God who created the world as sum of total things, and where greatness, multitude, and variety all coexist to witness his great power. Ultimately, the Cardinal Bellarmino had already praised in the same years that the communion with God could be achieved by contemplating the created things and that landscape painting was a visual mean to spiritual ends.[26] In this view, the contextualization of biblical scenes within the Flemish detailed narrative of natural elements contributes to illustrate not earthly existence but a supernatural truth.

## 4.6  The Architecture of Domenico Fontana

With Fontana, popes began the tradition of using northern Italian architects. Born in the Swiss Ticino, he was an "all-in-one artist" able to provide integrated services at good rates. Fontana, like his nephew Carlo Maderno and Maderno's nephew Francesco Borromini, embodied the idea of art and entrepreneurship within the same person. He started out his career in Rome as a stucco decorator, and in a short amount of time he was able to set up a construction business that could compete with the local architects, with the variety of services offered and with the ability to provide quickly materials and labor required for the projects.[27]

Fontana never built a church for Sixtus, for he was mostly employed to erect palaces and obelisks, and to straighten out new streets. However, his

---

[26] In 1566 the Cardinal Roberto Bellarmino wrote *The Ascent of the Mind to God by a Ladder of Things Created* (London, 1928), in which he discussed the position of man in a middle way of a ladder that can bring man, through the contemplation of nature, to the spiritual ascension toward God.

[27] Fontana excelled in all the arts since his training was based on the tradition of the early medieval Lombard Comacine Masters (*Magistri Comacini*), stonemasons who gave to Lombardy its preeminence in stone architecture between the Carolingian period and the Romanesque style. See Renzo Dionigi and Claudia Storti Storchi, *Magistri Comacini* (Milano: Cardano, 2007).

architectural interpretation of the Holy Steps followed the rigor of the Counter-Reformation church architecture, in which the new space created to house a relic belonging to Jesus's Passion was adapted to captivate the attention toward the main central staircase. In the facade, no single structural element prevails over another, and the whole composition conveys an unadorned stability. No central window has been emphasized over another, since the architect had already built a new loggia for papal blessings in the transept of Saint John in Lateran. An entablature with a series of tripartite triglyphs splits the facade in two horizontal blocks of the same size, slightly enhancing its height.

In almost all the projects he carried out for Sixtus V, Domenico Fontana followed the principles of Roman architecture that were exemplified already in the Pantheon and in the early Christian basilicas, where a minimal exterior decoration opposed a monumental interior. The lower part of the facade of the Holy Steps (fig. 40) recalls the regularity of the arches of the Roman aqueduct of Nero flanking the building; on the other hand, the upper level mimics the windows of Palazzo Farnese, designed by Vignola in 1543. The main two orders employed are the Doric at the bottom and the Ionic in the upper level; they are expressed not with columns but with non-supporting pilasters slightly projecting outward, since the architecture of the Counter-Reformation is sober and synthetizes all past experiences. The emphasis on the arrangement of space, with an eye on function rather than form is at the core of Fontana's architecture. The new meaning of the buildings planned by Fontana is that the construction is no more an edifice but a place where the heart is changed. Architecture became a performative form of theology, like the religious functions that Sixtus reenacted according to the early Christian practices.

At the time of Sixtus V, Rome had approximately one hundred thousand inhabitants, and unemployment was very low. The renewal of Rome he sought brought a flock of many craftsmen and unskilled laborers who could be trained by Fontana and by the major painters who had already established workshops.[28] Domenico was in charge to make come true the papal

---

[28] A general overview of the socio-economic condition of Rome under Sixtus is in Sandro Benedetti. *L'Arte in Roma nel Secolo XVI 1. L'architettura.* (Bologna: Cappelli, 1990), 491–544.

dream of reshaping Rome as the New Jerusalem. To accomplish the pope's vision, he had to create new buildings but—most important of all—he had to make them more meaningful through a system of interlinked streets that could facilitate the papal processions and the visit of the pilgrims to the main religious landmarks of Rome. The Via Sistina is an example of the new network of roads conceived by Sixtus and set into place by the architect when it was necessary to create the connection between the Basilica of Santa Maria Maggiore and the church of Santa Maria del Popolo, added by the pope to the pilgrimage to the Seven Churches already instituted by Filippo Neri.

Fontana's skills and efficiency represent a step toward establishing architecture as a respected profession; its practice was a path toward the liberation of architecture, far more than the procedures of painters and sculptors, from the bonds of the medieval guild system.

## LIST OF IMAGES CHAPTER FOUR

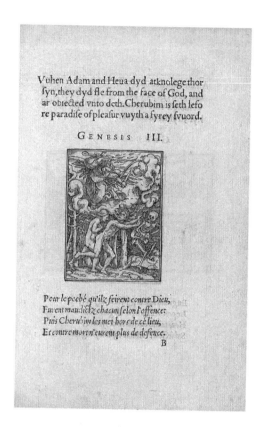

Figure 28: Hans Lutzelburger, *Expulsion of Adam and Eve*, etching, Alte Pinakotek Munich, Germany, 1538.

Figure 29: Cesare Nebbia and Giovanni Guerra with a landscape provided by Paul Bril, *Dream of Jacob*, fresco, left staircase, Holy Steps, 1588.

Figure 30: Cesare Nebbia, *Christ Crowned with Thorns*, fresco, Oratory of Gonfalone, Rome, 1576.

Figure 31: Cesare Nebbia, *Christ Meeting the Three Marys*, fresco, Cappella Borghese, Church of SS.ma Trinita dei Monti, Rome, 1575.

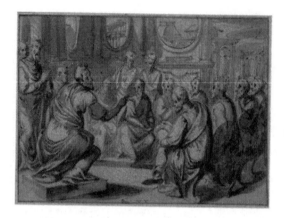

Figure 32: Giovanni Guerra,
*Saint Paul Preaching at Ephesus*,
drawing, Uffizi Museum, 1578.

Figure 33: Giovanni Guerra,
*Expulsion of Adam and Eve*,
fresco, Holy Steps, 1588, Rome.

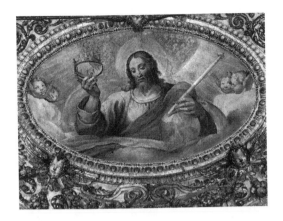

Figure 34: Cesare Nebbia,
*The Redeemer*, fresco, ceiling
of the church of Santa
Susanna, Rome (1581).

Figure 35: Ferrau' Fenzoni, *Moses
and the Brazen Serpent*, Fresco,
Holy Steps, Rome (1587).

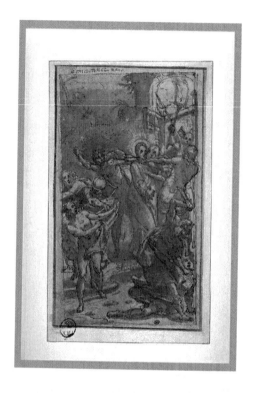

Figure 36: Cesare Nebbia, *Kiss of Judah, Arrest of Christ, Peter Cuts the Ear off Malchus*, drawing with pen and ink, (231 x 151 mm), Louvre, Cabinet des Dessins (inv. 1062), Paris, (1588).

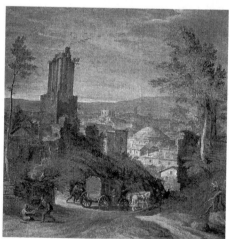

Figure 37: Paul Bril, *Roman Ruins,* Fresco, Torre dei Venti, Vatican (1578).

Figure 38: Paul Bril, *Jonah Thrown into the Sea,* Fresco, Holy Steps, (1587).

Figure 39: Paul Bril, *Jonah Disgorged by the Whale,* Fresco, Holy Steps, (1587).

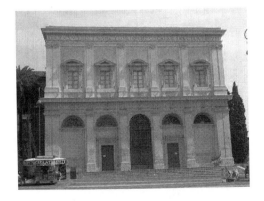

Figure 40: Domenico Fontana, *Facade of the Holy Steps,* travertine limestone and stucco, Rome (1588).

# CONCLUSION

## THE HOLY STEPS AS ACHIEVEMENT OF SALVATION

In the area of town planning, Sixtus was a rare statesman who in only five years succeeded in organizing, assembling, and executing his plans. Rome's urban development already had taken an energetic leap toward the southeast with his predecessors. From the deserted Quirinal Hill, Pius IV (1559–1565) shot a straight line across one and half miles to Michelangelo's Porta Pia (1561). This street was named the Strada Pia after the pontiff. Sixtus's immediate predecessor, Gregory XIII (1572–1585), straightened out the old road that connected Santa Maria Maggiore with the Basilica of Saint John in Lateran, which is today called Via Merulana.

With his accession to power, Sixtus found a series of fragmentary developments extending from west to east. He was able to bring them all together into a unified master plan. The main impulse for this transformation was his willingness to show the vitality of the church he was leading at that time after the Reformation initiated by Martin Luther. The desire of the Franciscan pope was to make the whole of Rome a single holy shrine, where pilgrims could visit, in only one day, the main churches and participate in the religious functions. Thus, one could by foot, horse, or in a carriage, start from whatever place in Rome and continue virtually in a straight line to the sacred places of the Eternal City. Since the end of the Roman Empire, many areas within the Aurelian walls were uninhabited and linked by a simple assembly of roads that were converted by the Franciscan pope into an integrated urban transportation system.

In the Holy Steps, Sixtus V created the right amalgam among the different religious experiences of the Counter-Reformation. On one side, he

adopted the principles of the more moderate Carlo Borromeo and Filippo Neri, who promoted a Christian Humanism based upon the interest toward religious history and philosophy. On the other hand, Pope Peretti's additions to the medieval Sancta Sanctorum linked his patronage to the early mysticism that was fostered by the Jesuits during the Renaissance period.

The aim of the entire ensemble of the Scala Santa is more didactic than pleasure giving. The main thrust of the program, which extols the glory and the triumph of the Catholic Church led by its bishop, is a message that was being propagated at this time in history by a church that liked to regard itself as triumphant. Although the Protestants and the Turkish threats were particularly vivid in the minds of the post-Tridentine popes, the enactments of the dictates of the Council of Trent during the 1580s had effectively set the stage for a church that viewed itself as victorious. The crucial contribution of Sixtus V to the history of the papacy was to enforce the conciliar enactments through the value of sacred history and the didactical role of the religious images. It was during his pontificate that the transfer from a primarily defensive stance to a more confident Church Militant found its first really grandiose manifestations.

In order to propagate the spirit of a Christian renewal, Pope Sixtus V Peretti embraced the ideas of Cesare Baronio's *Annales Ecclesiastici* on command of Filippo Neri. The pope supervised the completion of the first two books, whose main argument was that sacred history was superior to secular history; sacred history was, in effect, timeless, since the authority of the Church and of its vicar were preordained by God and could be traced back to man's earliest beginnings in the Old Testament. In this regard, the cycle of the Holy Steps is a visual parallel to Baronio's *Annales*. The history of the Passion of Jesus, represented in the main staircase, follows chronologically the events narrated in the Gospels and is meant to show how the Church preserves its original features throughout time. The impetus for Baronio, as for Sixtus, was not only to rebut the centurions of Magdeburg, but also to prove that the doctrine and institution of the Roman Catholic Church, as recently defined at Trent, adhered to the pristine form set forth by Christ and followed during apostolic times. Since Sixtus himself had been appointed by

Pius V to the commission of cardinals instituted in 1571 with the express purpose of determining the best manner in which a reply should be made to the *Ecclesiastica Historia* of Magdeburg, it was natural for him to use the program of the Lateran to refute the essential claim of the centurions that the pope was to blame for the church's present issues. The simultaneous presence of Old and New Testament scenes in the same building was intended to prove that all earthly history, be it pagan, Hebrew, or Christian, was part of a divinely ordained plan instituted by God to culminate with the attainment of the Heavenly City. On the other hand, if Baronio's goal was to argue that the history of the Church was linear and uninterrupted, Bellarmino's ideas tended more to extol the value of the non-written tradition to justify the culture of obedience. In fact, Bellarmino's formulation of the pope's indirect power (*potestas indirecta*) fits well in the Counter Reformation period when the main European superpowers tried to handle religious matters on their own. According to the cardinal, although some kings withdrew from the Church of Rome, they should not be considered heretic and could always be readmitted to the Catholic faith. Since the major concern of the pope was to instruct the faithful to live in accord with Christian principles, his authority, as shown in the episodes of Moses at the Holy Steps, was to take care of mankind's salvation even if he does not have temporal jurisdiction. It is no accident that the culminating fresco at the top of the Holy Steps is a crucifixion scene: after the Eucharist, the Cross, as another manifestation of Christ's body, was among the most hotly debated issues during the Counter-Reformation. For the Catholics, the Cross is worthy of veneration as a symbol of the divine nature of Christ. On the other hand, the Protestants had adopted the stances of Byzantine iconoclasts; for them the Cross recalls the Passion but it does not retain divine quality.

Sixtus attempted to fashion Rome as a world capital where the pope would reside as eternal arbitrator of the balance of power among temporal states. Although rationalism and the Reformation propelled developments in another direction, his religious faith inspired him with an optimism that enabled him to accomplish in a short amount of time the seemingly impossible.

# APPENDIX

## PRIMARY SOURCES

TEXT 1: Charles Borromeo on the Requirements for the Decoration of a Church's Facade:
"...Nella pia decorazione della facciata, ideata secondo la struttura della chiesa e la grandezza dell'edificio, l'architetto prenderà cura non solo che non vi sia nessuna immagine profana, ma anche che quanto rappresentato lo sia il meglio possibile, a seconda delle disponibilità, e si accordi con la santità del luogo..."

(From: Charles Borromeo. *Instructiones Fabricae Et Supellectilis Ecclesiasticae.* México, D. F: Universidad Nacional Autónoma de México, 1985, 63).

TEXT 2: Charles Borromeo on the Numbers of Doors in a Church:
"...Le porte si apriranno sulla facciata della chiesa; saranno dispari, e almeno tante quante sono le navate della chiesa stessa. Se la chiesa è a più navate, la mediana, ove possibile, data la sua ampiezza, abbia alla propria estremità tre porte; se la chiesa possiede un'unica navata, vi siano almeno tre porte sulla facciata: infatti le basiliche romane insegnano che le entrate della chiesa debbono essere molteplici per vari motivi, tra cui la separazione degli uomini dalle donne..."

(From: Charles Borromeo. *Instructiones Fabricae Et Supellectilis Ecclesiasticae.* México, D.F: Universidad Nacional Autónoma de México, 1985, 68–69).

TEXT 3: Charles Borromeo on the Construction of the Sacred Tabernacle Containing the Eucharist:

"...Poichè per decreto provinciale si deve collocare il tabernacolo della Santissima Eucarestia sull'altar maggiore, converrà dare qui qualche istruzione. Nelle chiese più insigni, ove possibile, sarà opportuno che esso sia di lamine d'argento o di bronzo, in entrambi i casi dorate, o di marmo prezioso. Il corpo del tabernacolo, elegantemente lavorato e ben compatto nelle sue parti, scolpito con immagini dei misteri della Passione di Cristo e decorato con dorature in alcuni punti, presenterà un'ornamentazione veneranda e pia. All'interno dovrà essere rivestito di tavole di pioppo o di altro legno del genere, perchè la Santissima Eucarestia sia protetta, grazie a tale rivestimento, dall'umidità del metallo e del marmo..."

(From: Charles Borromeo. *Instructiones Fabricae Et Supellectilis Ecclesiasticae.* México, D.F: Universidad Nacional Autónoma de México, 1985.81-85).

TEXT 4: Gabriele Paleotti on the Condition of the Artist:

"...L'altra è che, ricercandosi nelle imagini, quanto alle sacre, che muovano i cuori de' riguardanti alla divozione e vero culto di Dio, i pittori, per non essere communemente meglio disciplinati degli altri nella cognizione di Dio, né essercitati nello spirito e pietade, non possono rappresentare, nelle figure che fanno, quella maniera di divozione ch'essi non hanno né sentono dentro di sé; onde si vede per isperienza che poche imagini oggi si dipingono, che produchino questo effetto..."

(From: Gabriele Paleotti. *Discorso intorno alle immagini sacre e profane, (1582).* Città del Vaticano: Libreria Editrice Vaticana, 2002, 55–58.)

TEXT 5: Gabriele Paleotti on the Comparison between the Utility of the Images Seen by Many and the Books read only by Intellectuals:

"...Con più fecondità si diffonde nelle pitture che nei libri, quando però le pitture possono esprimere quello che i libri contengono; perciò che i libri

sono letti solo dagl'intelligenti, che sono pochi, ma le pitture abbracciano universalmente tutte le sorti di persone..."

(From: Gabriele Paleotti. *Discorso intorno alle immagini sacre e profane (1582)*. Città del Vaticano: Libreria Editrice Vaticana, 2002, 62–63.)

TEXT 6: Gabriele Paleotti on the Assimilation of Oratory to Painting:
"...Intorno a cio'che dicemmo che, solendosi nell'arte oratoria assignare tre principali, che sono il dilettare, l'insegnare et il commovere, non è dubbio che i medesimi cadono ancor notabilmente nella pittura..."

(From: Gabriele Paleotti. *Discorso intorno alle immagini sacre e profane (1582)*. Città del Vaticano: Libreria Editrice Vaticana, 2002, 70.)

TEXT 7: Letter of the Benedictine Abbot Angelo Grillo after his Visit to Rome in 1590:
"...Here I am in Rome, and yet I cannot believe my eyes: so great are the changes in the buildings, the streets, the piazzas, the fountains, the aqueducts, the obelisks, and the other marvels with which the glorious memory of Sixtus has beautified this old and ruinous city that I cannot recognize nor find, so to speak, any trace of that old Rome I left ten years ago. It is as if a new Rome has risen from the ashes..."

(From: Ludwig von Pastor, *The History of the Popes from the close of the Middle Ages. Drawn from the Secret Archives of the Vatican and other Original Sources*. St. Louis: Herder, 1898, XXII, 305).

Text 8: *Avviso* dated 1587 on the Creation of Via di Porta San Giovanni Terminating at the Holy Steps and the Consequent Opposite Papal Decision to Continue the Road beyond the Lateran, as it is still today:
"...Nostra Santità e' tuttavia intento a far stendere quelle strade nuove per retta linea et a far finire la fabrica di San Giovanni Laterano e restare la

cappella del Sancta Sanctorum in isola, ma qualche pio avertimento l'ha levato di questo pensiero..."

(From: Ludwig von Pastor, *The History of the Popes from the Close of the Middle Ages. Drawn from the Secret Archives of the Vatican and other Original Sources.* St. Louis: Herder, 1898. XXII. 428).

Text 9: Description by Domenico Fontana of the Removal of the Holy Steps and their Placement in the new Building in only one Night (November 1587): "...Cominciossi a levare l'ultimo scalino di sopra seguendo a basso e tenendo il medesimo ordine quando si mettevano in opera, al contrario di quello che ordinariamente far si suole accioche' non vi si dovesse caminare con li piedi sopra, gia che' Pontefici istessi divotamente van salendo quelle inginocchione, e tutta l'opera fu in una sol notte posta in essecutione, restando in tal modo la Scala Santa intatta e non contaminata dai piedi dei mortali....."

(From: Domenico Fontana *Della Transportatione dell'Obelisco Vaticano*. Milano: Ed. Il Polifolio, 1978, 44).

Text 10: On the Artists' Relationships within the Workshop at the Holy Steps and on the Role of Giovanni Guerra as *Inventor:*
"...Onde narrasi che Giovanni Guerra, il quale ha messo in stampa diverse carte, facesse egli numerosissimi disegni di diverse historie del testamento vecchio e nuovo; e voleva che li Principi grandi, senza occuparsi in perder tempo nella lettura degli storici, solo nel mirar questi disegni con facilita' comprendessero le historie. Cesare Nebbia faceva li disegni e Giovanni Guerra inventava li soggetti delle storie che dipinger si deveano. Havendo egli espresso un suo pensiero sopra la forma e il sito del Paradiso terrestre, tra l'historie dipinte per ornamento della Scala Santa...."

(From: Giovanni Baglione, *Le Vite de' Pittori, Scultori et Architetti: dal Pontificato di Gregorio XIII fino a tutto quello d'Urbano VIII (Roma, 1649)*. Bologna: A. Forni, 1975, 50).

Text 11: Giovanni Baglione Describes the Activity of the Flemish Painter Paul Bril at the Holy Steps:
"…Nel papato di Sisto V fece i paesi nelle storie da' pittori in quel tempo condotte. Nella Scala Santa, alla man dritta, sono due suoi paesi molto belli: una si e' nella volta, quando gettano il profeta Giona in mare, ed e' ingoiato dalla balena; l'altra da basso quando la balena butta Giona fuori dal ventre; la Balena e' eccellentemente fatta, e le opera sono con gran franchezza terminate, e a buon fresco concluse…."

(From: Giovanni Baglione, *Le Vite de' Pittori, Scultori et Architetti : dal Pontificato di Gregorio XIII fino a tutto quello d'Urbano VIII (Roma, 1649)*. Bologna: A. Forni, 1975, 196–197).

# BIBLIOGRAPHY

## PRIMARY SOURCES

Ambrose, Saint. *De Officiis*. Oxford, New York: Oxford University Press, 2001.

Baglione, Giovanni, and Costanza Gradara Pesci. *Le vite de' Pittori, Scultori et Architetti: dal Pontificato di Gregorio XIII fino a tutto quello d'Urbano VIII (Roma, 1649)*. Bologna: A. Forni, 1975.

Baronio, Cesare. *Annales Ecclesiastici*. Barri-Ducis: L. Guerin, 1864.

Bellarmino, Roberto. *The Ascent of the Mind to God by a Ladder of Things Created*. London, 1928.

Borromeo, Charles. *Instructiones Fabricae Et Supellectilis Ecclesiasticae*. 1a ed. Estudios y Fuentes Del Arte En México/Instituto De Investigaciones Estéticas 49. México, D.F: Universidad Nacional Autónoma de México, 1985.

Climacus, John. *The Ladder of Divine Ascent*. New York: Paulist Press, 1982.

*Collectionis Bullarum Sacrosanctae Basilicae Vaticanae*. Romae: Jo. Maria Salvioni Typographus Pontificius Vaticanus, 1747.

da Firenze, Mariano, and Enrico Bulletti. *Itinerarium Urbis Romae.* Roma: Pontificio Istituto di Archeologia Cristiana, 1931.

Duchesne, L., and Cyrille Vogel. *Liber Pontificalis.* Paris: E. de Boccard, 1955.

Falda, Giovanni Battista. *Il Nuovo Splendore Delle Fabriche in Prospettiva Di Roma Moderna.* Roma: Carlo Losi, 1773.

Felini, Pietro Martire, and Stephan Waetzoldt. *Trattato Nuovo delle Cose Maravigliose dell'Alma Citta di Roma, 1610.* Berlin: Hessling, 1969.

Fontana, Domenico. *Della Transportatione dell'Obelisco Vaticano.* Milano: Ed. Il Polifolio, 1978.

Marangoni, Giovanni. *Istoria dell'Oratorio di San Lorenzo.* Roma, 1747.

Moroni, Gaetano. *Dizionario di Erudizione Storico-Ecclesiastica da S. Pietro sino ai Nostri Giorni.*Venezia: Tipografia Emiliana, 1840.

Paleotti, Gabriele. *Discorso Intorno alle Immagini Sacre e Profane (1582).* Città del Vaticano: Libreria Editrice Vaticana; Cad & Wellness, 2002.

Perosa, Alessandro. *Giovanni Rucellai ed il suo Zibaldone.* London: Warburg Institute, University of London, 1960.

Schroeder, Henry Joseph. *Canons and Decrees of the Council of Trent.* St. Louis, Missouri: B. Herder Book Co., 1950.

Valentini, Roberto. *Codice Topografico della Città di Roma.* Roma: Tipografia del Senato, 1940.

Vasari, Giorgio. *The Lives of the Artists.* New York: Penguin Books, 1987.

# SECONDARY SOURCES

Barocchi, Paola. *Trattati d'Arte del Cinquecento fra Manierismo e Controriforma.* Bari: G. Laterza, 1960.

Benedetti, Sandro. *L'Arte in Roma nel Secolo XVI 1. L'Architettura.* Bologna: Cappelli, 1990.

Bonaventura, and Collegium S. Bonaventurae (Roma). *Seraphici Doctoris S. Bonaventurae Decem Opuscula ad Theologiam Mysticam Spectantia.* Ad Claras Aquas (Quaracchi): Collegium, 1900.

Bonaventure of Bagnoregio. *The Life of St. Francis.* San Francisco: Harper, 2005.

Branner, Robert. *St. Louis and the Court Style in Gothic Architecture.* London: A. Zwemmer, 1965.

Cappelletti, Francesca. *Paul Bril e la Pittura di Paesaggio a Roma: 1580–1630.* Roma: Ugo Bozzi Editore, 2006.

Dionigi, Renzo, and Claudia Storti Storchi. *Magistri Comacini.* Milano: Cardano, 2007.

da Celano, Tommaso. *San Francesco:Vita Prima.* Torriana: Orsa Maggiore, 1993.

Eitel-Porter, Rhoda. "Artistic Co-Operation in Late Sixteenth-Century Rome: The Sistine Chapel in S. Maria Maggiore and the Scala Santa." *The Burlington Magazine* 139, no. 1132 (July 1, 1997): 452–462.

Eitel-Porter, Rhoda. *Der Zeichner und Maler Cesare Nebbia*, 1536–1614. München: Hirmer, 2009.

Esposito, Daniela. *Tecniche Costruttive Murarie Medievali: Murature "a tufelli" in Area Romana*. Roma: "L'Erma" di Bretschneider, 1998.

Festa, Gianni. *Martire Per La Fede: San Pietro Da Verona Domenicano e Inquisitore*. Domenicani 29. Bologna: ESD, 2007.

Fiocchi, Nicolai, Vincenzo, Fabrizio Bisconti, and Danilo Mazzoleni. *The Christian Catacombs of Rome: History, Decoration, Inscriptions*. Regensburg: Schnell & Steiner, 2009.

Forciroli, Francesco, Sonia Cavicchioli, and Giorgia Mancini. *Vite dei Modenesi Illustri*. Modena: Aedes Muratoriana, 2007.

Frajese, Vittorio. *Il Popolo Fanciullo: Silvio Antoniano e il Sistema Disciplinare della Controriforma*. Milano: Angeli, 1987.

Gardner, Julian. *Sancta Sanctorum*. Milano: Electa, 1995.

Gombrich, E. H. *Norm and Form: Studies in the Art of the Renaissance*. London: Phaidon, 1966.

Guarrera, Gabriele. *Via delle Sette Chiese in Roma: un Percorso Storico, Archeologico, Paesistico*. Roma: Gangemi, 1997.

Hall, Marcia B. *Rome*. New York: Cambridge University Press, 2005.

Haskell, Francis, and Nicholas Penny. *Taste and the Antique: the Lure of Classical Sculpture, 1500–1900*. New Haven: Yale University Press, 1981.

Hendriks, Carla. *Northern Landscapes on Roman Walls: the Frescoes of Matthijs and Paul Bril*. Florence: Centro Di, 2003.

Herz, Alexandra. "Cardinal Cesare Baronio's Restoration of SS. Nereo Ed Achilleo and S. Cesareo de'Appia." *The Art Bulletin* 70, no. 4 (December 1, 1988): 590–620.

Irenaeus. *Against the Heresies*. New York: Paulist Press, 1992.

Iversen, Erik. *The Obelisks of Rome*. Copenhagen: Gad, 1968.

Jones, Pamela M. *From Rome to Eternity: Catholicism and the Arts in Italy, ca. 1550–1650*. Boston: Brill, 2002.

Kitzinger, Ernst. *Studies in Late Antique, Byzantine and Medieval Western Art*. London: Pindar Press, 2002.

Krautheimer, Richard. *Rome, Profile of a City, 312-1308*. Princeton: Princeton University Press, 1980.

Lucas, Thomas M. *Landmarking: City and Church within the Jesuit Urban Strategy*. Chicago: Jesuit Way, 1997.

Macioce, Stefania. *Undique Splendent : Aspetti della Pittura Sacra nella Roma di Clemente VIII Aldobrandini (1592–1605)*. Roma: De Luca Edizioni d'Arte, 1990.

Madonna, Maria Luisa. *La Roma di Sisto V. Le Arti e la Cultura*. Roma: De Luca, 1993.

Masetti Zannini, Gian Ludovico. *Pittori della Seconda Metà del Cinquecento in Roma*. Roma: De Luca, 1974.

McGinness, Frederick J. "Preaching Ideals and Practice in Counter-Reformation Rome." *The Sixteenth Century Journal* 11, no. 2 (July 1, 1980): 109–127.

Muratori, Lodovico Antonio. *Rerum Italicarum Scriptores*. Sala Bolognese: A. Forni, 1977.

*Oltre Raffaello: Aspetti della Cultura Figurativa del Cinquecento Romano*. Exhibition Catalog. Rome: Multigrafica Editrice, 1984.

Orbaan, Johannes Albertus Franciscus. *Sixtine Rome*. New York: Baker and Taylor, 1911.

Origen. *Homilies on Numbers*. Downers Grove, IL: IVP Academic, 2009.

Ostrow, Steven F. *Art and Spirituality in Counter-Reformation Rome: the Sistine and Pauline Chapels in S. Maria Maggiore*. Cambridge: Cambridge University Press, 1996.

Pastor, Ludwig. *The History of the Popes from the Close of the Middle Ages. Drawn from the Secret Archives of the Vatican and other Original Sources*. St. Louis: Herder, 1898.

Pierguidi, Stefano. "Giovanni Guerra and the Illustrations to Ripa's Iconologia." *Journal of the Warburg and Courtauld Institutes* 61 (January 1, 1998): 158–175.

Rice, Louise. *The Altars and Altarpieces of New St. Peter's: Outfitting the Basilica, 1621–1666*. Cambridge University Press, 1998.

Robertson, Clare. *Il Gran Cardinale: Alessandro Farnese, Patron of the Arts*. New Haven: Yale University Press, 1992.

Romano, Serena. *Eclissi di Roma: Pittura Murale a Roma e nel Lazio da Bonifacio VIII a Martino V (1295–1431)*. Roma: Àrgos, 1992.

Rosand, David. "Ekphrasis and the Generation of Images." *Arion* 1, no. 1. Third Series (January 1, 1990): 61–105.

Signorotto, Gianvittorio and Maria Antonietta Visceglia. *Court and Politics in Papal Rome, 1492–1700*. Cambridge, UK; New York: Cambridge University Press, 2002.

Smith, Graham. *The Casino of Pius IV*. Princeton: Princeton University Press, 1977.

Tantillo, Mignosi. *Dimore Nobili del Tuscolo e di Marino*. Mostra Documentaria: Roma, Museo di Palazzo Venezia, Marzo-Maggio 1980. Roma: De Luca, 1980.

Warnke, Martin. "Italienische Bildtabernakel Bis Zum Fruhbarock." *Munchner Jahrbuch Der Bildenden Kunst* 19 (n.d.): 61–102.

Witcombe, Christopher and L. C. Ewart. "Sixtus V and the Scala Santa." *Journal of the Society of Architectural Historians* 44, no. 4 (December 1, 1985): 368–379.

Wittkower, Rudolf. *La Cupola di San Pietro di Michelangelo : Riesame Critico delle Testimonianze Contemporanee*. Firenze: Sansoni, 1964.

Wollesen-Wisch, Barbara Leslie. "The Arciconfraternita del Gonfalone and its Oratory in Rome : Art and Counter-Reformation Spiritual Values," Thesis (PhD), University of California, Berkeley, 1987.

Zuccari, Alessandro. *I Pittori di Sisto V*. Roma: Palombi, 1992.

Made in the USA
Middletown, DE
16 June 2016